T0063046

When I Fell
in Love with Life

When I Fell in Love with Life

Musings of a Cancer Survivor

Geetha Paniker

PARTRIDGE

A Penguin Random House Company

To order additional copies of this book, contact
Partridge India
000 800 10062 62
orders.india@partridgepublishing.com

www.partridgepublishing.com/india

Contents

Dedicated to
Family & Friends

Edited by:
Preeja Aravind.

Acknowledgement

As I look back on my life, I realize "Writing is a gift" and the toddler's steps of writing was gifted to me by my father who instilled the habit of diary writing. My father-in-law gifted me the confidence with his stamp of approval as a great critic. I evolved as a writer with my experience in the editorial board of the school Magazine, during my tenure as a teacher in Montfort School, Mylapore. I owe a lot to my husband Krishna Paniker who always allowed me to pursue my little dreams and my sons Rakesh, Rohit and Rahul who stood by me in everything I wanted to do.

The thought of publishing what I wrote was the inspiration of a few close ones like, Arun M Sivakrishna who came as a son and blessing into my life, my niece Beena K and Saipriya Manoharan; and my two friends Asha Menon and Suja Rachel David Joseph. My gratitude extends to those few friends in face book who always appreciated my words. I thank all my family members and friends who encouraged me.

"Thank you" will be a small word to show my gratitude to Preeti Warrier for her foreword, Asha Menon for the introduction, Dr. Siva Kumar for his words of appreciation, Anoop Thomas and Suja for the overview.

I have no words to voice my gratitude to Preeja Aravind who edited my manuscript with dedication in spite of her busy schedule with her one and a half year old son.

A special thanks to Arun M Sivakrishna for allowing me to use his beautiful click as my cover page.

My gratitude to Partridge Publishers for their publishing package.

Introduction

A post graduate in cancer, Mrs. Geetha Paniker is someone who has tamed the crab more than once, with sheer grit, stoicism and immense positivity. Though she has been asked to stay alert always, she is all set to clip the pincers were it --- God forbid --- to raise its claws again.

Geetha chose to see the cancer as her spiritual guru that awakened and enlightened her. Cancer for her became a teacher that gave her a new perspective of life.

Cancer, to her, was a taskmaster that kept her body and mind alert at all times. It was an inspiration that perked up the muse in her and helped bring out her creative best. Through her notes --- jotted down whenever inspiration struck --- she does not merely share her experiences with cancer but enunciates how to deal with the trauma of chemotherapy and its side effects; how to put up with the daily aches, sleepless nights and prolonged moments of discomfort, and how to keep oneself motivated to fight a battle and win it like a true warrior, and ... how to celebrate cancer!!

Yet, it's not just a chronicle of her everyday medical experience. This compilation is sure to enlighten every reader to think positive, to connect with nature and recharge one's energy and radiance levels, to be thankful for every moment of one's life, and to appreciate and cherish each day.

"May be the journey isn't so much about becoming anything. May be it's about unbecoming everything that isn't you so you can be who you were meant to be in the first place."

Cancer made her "unbecome" everything she used to be and become the beautiful and strong soul she is today!

"I prefer to live a full life, even when my life is a rollercoaster ride with lots of ups and downs, twists and turns, not knowing what's next --- a not-so-gentle drop or a sharp turn or a steep uphill climb. I choose to live without fear, with inner power and strength, to be a glowing torch."

Filled with many such heartfelt declarations, this book is an enlightening guide to anyone who is going through such traumas in life and wants to see that bright light at the end of a dark tunnel.

Asha Menon

Preface

It was a usual day for me at my clinic in May 2011. But, one of the patients I saw that day, I realised, was not a usual one. No tear no fear in her but only courage and confidence. That was Mrs. Geetha Paniker -- an epitome of optimism. Who else could hear music in the MRI machine noise? Who else could feel the beauty in baldness? Who else could fall in love with cancer?

When you go through the writings of Mrs. Geetha Paniker, you get drenched in the beauty of nature --- at times its grandeur even suffocates you! But, you must understand, that is how buoyant people survive. Their sanguine minds see the extreme beauty in everything --- be it nature or cancer. That is how '(self) guided imagery' in psychology works.

The other aspect I enjoyed in this collection is the quotes. Being a literature lover, Mrs. Geetha Paniker has sprinkled these quotes liberally throughout her book which could energise even the most depressed minds.

To sail unruffled through bilateral triple negative breast cancer needs great optimism. By reading this book, let this belief, faith and hope be infected to other cancer fighters, because they would not be cancer survivors, but winners!

Dr. S. Siva Kumar, MBBS, MD, DM – Oncology (Oncologist),
Sai Balaji Clinic,
Mylapore,
Chennai.

Foreword

It takes just a moment for life to change. Geetha Paniker's such moment came when she was diagnosed with cancer. In a span of four years the cancer returned twice, each time it had to be beaten back with aggressive treatments. Geetha's journey has been difficult. This book is a testimony to her indomitable spirit: that she can still find beauty and hope in life. Poetry comes easily to Geetha who is a teacher of English.

Studies show that the rate of cancer in India has gone up. Most cancers are caused by environmental factors. Yet we continue to pollute our lands and rivers, smoke cigarettes and use cell phones with impunity. All in the name of comfort, wealth and happiness!

Geetha finds a blessing in her illness. It teaches her that it is the simple things in life; a sunset, a moon rise or a singing bird that gives true joy. Nature is the kindly mother who is her friend from whom she draws courage, in whose bounty she can submerge herself. This is a very valuable lesson that her book gives us in beautiful sentences and verses that come from her heart. In our blind race for development let us not make nature a casualty. Let us not barter away the future for short-term gains. Let us recognize that we are nature too, and that by destroying our surroundings we destroy ourselves.

Prita Warrier
Author of Circle of fate.

1

Mammograms of life's beauty

Mammogram is an X-ray of the breast that is taken with a device that compresses and flattens the breast. It plays a vital role in early detection of breast cancer and helps in decreasing the threats to life. Every woman dreads this for the fear of pain when the breast is literally crushed between two glass plates. For some, though, it is painless. I, on the other hand, had heard of the excruciating pain it causes.

The first time I detected a lump and was advised to do a screening and mammogram, I had prepared myself to face it as a new challenge. My first time, however, was not a painful one. Later, I had to repeat it on my left breast, and each scan or test was a new experience and challenge. I took it in a way that made me to go through it without any fear. I have never feared anything in life since.

The last experience of my mammogram --- before my second mastectomy --- was very painful. It was a completely new experience for me: a challenge of a new pain as the technician was unable to get a clear picture. In both angles, it was so painful that I had tears in my eyes without me knowing it. I took it as a new experience: of knowing how it becomes painful for many.

Pain has its own beauty: it proves to you that you are still susceptible and that makes you alive. By the end of the day, the

screening had made my skin peel off and burn. It was a new experience that challenged me. I do feel pain, but I preferred to treat it as a proof of my life and as a beautiful experience rather than moan over it. When I look back, after having been stripped of the pride and beauty of womanhood, I don't feel any remorse of having lost it; only thankful for having challenged by it and lived through it.

Woman's beauty and pride,
Sometimes is crushed
Between two glass plates of,
An X-ray machine.

The breast once fondled,
And suckled by my babies,
Is brutally battered
And pain reigns in.

Strangers under light,
Only a scar remains,
Becoming a wasteland of,
Once a passion land.

It makes no difference,
For it served its purpose,
True love is not lust,
While beauty still reflects.

Why be devastated for,
That which the crab invaded
Life is so precious,
And nothing else matters.

2

Falling in love with myself

"Are you in love?" is a question that baffled me; a question that led me down my memory lane to introspect. Amused at the question posed to me at the threshold of age 60, I mused over it for a long time with mischief in my heart.

My love story with cancer, the challenges of the last four years --- these have made me fall in love with myself.

The creeping crab brought out the real, expressive me who loved nature from childhood, one who had a rare and special connect with trees and everything in nature. One who visualised all that she felt and read! It was the exuberance in me that always loved all innate and pristine things in nature with a passion.

That me, I had hidden in some remote corner of the mind, heart and soul; one who sacrificed everything held dear for the love and welfare of the little family. The expressions of whose life, though, were those of a born fighter and rebel. With the burdens and challenges of life, I turned into one that started loving adversity, the land of unknown, one who feared nothing, but held the values instilled by my parents as dear as life.

The inevitable of life taught me the pain of loss and the value of life; still I never bothered about myself as I slogged for the family.

When the heart started racing faster than I could comprehend and landed me in a hospital bed, it made me sit up and think. I realised it was time to quit slogging, but I still continued until my family doctor gave an ultimatum: stop and relax.

Cancer was the best thing that happened to me. It made me what I am today: one with nature, loving everything about nature, one with a zest to dare and challenge myself as I used to do as a child, as an adolescent, as a teenager --- until I got married. After that, my life was not my own. It revolved around so many people. My world was my joint family, and later it was my little family.

Life swept me along many paths --- but all for my family. I believed firmly that a woman is like a river. If she flows within the boundaries, then she is revered and respected. If she goes beyond the boundaries, she is like the floods that can devastate and destruct.

Cancer made me love myself with all the passion in my soul and that took me through my fight of life. Yes. I am in love with that self who had loved to be with nature, the 'me' who was lost in the rat race of day-to-day living. I am in love with myself.

Love is a feeling I always knew,
The feelings that goes on in me,
And got lost somewhere,
In my life's journey.

The purest gift not of money
That is inside my heart and soul,
With an undying passion,
Of the truest feelings.

I can't exchange it for anything,
Nor let it fly away like a dove,
No matter what had happened,
I am in love with myself.

3

Passions of my Life

Cancer is a disease of the body, not your soul. Cancer is a correlation between a positive attitude and the fear of loss and pain of going through surgery, chemotherapy and radiation. In case of breast cancer, it is the fear of the feminine ethos and the confusion of continuing a normal life.

More than the colour pink for breast cancer, it is a promise for a cure that every woman who goes through it hopes for. Are you passionate? Pink evokes the passion of romance, commitment and emotions. Going through the trauma of chemotherapy makes a woman stronger with a lot of mixed feelings that surface within the heart and soul.

Passionate love is a feeling that burns within itself; for some it burns out and extinguishes on its own, at times replaced by a calm but strong bond or companionship. For others, it dies a natural death. True passion of an unfeigned love always remains alive in the soul. For many, over a period of time, it dies or stays dormant and springs back. It is a highly inflammable subject, an attitude towards love and its intensity. It is a connection to intimacy, passion and commitment, depending on the strength of these.

There is a vast difference between love and passion --- both very strong emotions that need understanding. Passion is a state of being euphoric and ecstatic if it lasts forever. It is

never complete without love. Love, is being in a state of living, knowing that in spite of all the fights and sacrifices, you truly love. While passion lasts, nothing matters and you are euphoric with love. A soulful gaze conveys everything.

True love is much more than the romance or passion, it's never lustful. There is always respect, honesty, compassion and commitment. It is also a deep understanding of each other's needs, desires and mutual satisfaction. Though passion does bring spice to life, something lacks the key factors to make it last forever.

In love, a deeper understanding is the essence, while in passion it is an ever-consuming fire in the soul. It is killed or goes into hiding due to a lack of understanding and the traumas of life's diseases. Even when you are crushed --- losing all your feminine parts --- the soul still burns with a passion of true love. You are just dead meat if you lack the feelings and emotions of an undying fire in you.

It is an understanding of life, an unfeigned love and passion that keep you alive to fight all the battle of life. One who understands nature and loves nature with a passion and the positive glow of life, the fire in them is always alive and they find everlasting joy in them.

An eye gazes into a soul,
A love not ensnared in a web of lust,
Or caged in a love of desires,
A love above all temptations.

A love that understands,
Waking and sleeping moments,
Utters the unsaid word of the heart,
In silent whispers.

The heart entwined in eternal love,
Is pure beauty of the soul,
Echoes of pounding heart,
Into unknown tides and shores.

4

A Radiated Life

Your life is always in radiation. When the creeping crab attacks, it invades your cells. Radiation therapy --- a part of the treatment --- is high-energy, powerful and lethal rays that damage and destroy the cancer cells. A high dose of these rays are given depending on how far the cancer has spread. It destroys the good cells, too, reducing your haemoglobin count that is checked every week.

I knew about radiation; I had also seen the machine and the procedure. It is limited to cancerous areas and the oncology-radiology doctor decides the time span of each radiation and the number of radiations. For some, it is nightmarish and frightening. When radiation doses are high, the cells are damaged beyond repair, and I was told that mine would be an aggressive treatment.

The day my treatment started, it was embarrassing than any fear in me. Lying on a cold steel bed, with ink marks over my scars, I felt numb and cold. I was strapped in; the machine was adjusted over me leaving me alone in that dark room with the machine whirling around making weird sounds. It was a new experience that again challenged me. I had no feelings in me nor did I feel any pain. Only when the skin became darker I knew of the powerful rays penetrating me.

You lose six precious minutes of your life to those powerful lethal rays. The procedure parched my throat and made me drink vegetable juice in one gulp. It was a new experience in life, a new learning to fight the emperor of maladies and win. I was determined to see it as a challenge. It is like going on a rollercoaster ride, feeling exhilarated and flushed, but feeling happy at the joy you derived.

Lying half dressed, disfigured,
Under a machine with an eye
That is programmed to kill
Whirling around and emitting strong rays.

Loneliness in an unspoken room
Smiling bland faces strap me
The buzz ringing through
That made me powerless.

Lying like a corpse
Still and without a breath
Losing precious minutes
Over a bed, that's steel cold.

The powerful rays rob me
Of my delicate skin
Raw wound, charred flesh
Raining pain on me.

I fight tooth and nail
Smile away my anguish
With a strength so wild
Like my passion of life.

5

Transitions through cancer

The transition in a woman's life when she loses her most important feminine part is like going into a cocoon and coming out like a beautiful butterfly. For me, it is realizing that beauty is not in physical appearance, but in inner strength and the positive glow you radiate. At this crucial crossroad of life, I am attracted to a flower as I am a lover of nature, who from childhood observed the flowers and the butterflies that are attracted to them, although the similarity is usually found between a flower and a woman.

Flowers are a delicate entity of beauty to behold: a thing of beauty that is a joy forever. A flower is admired, caressed, adorned, crushed, destroyed, used, misused or abused.

Much like a woman who is often compared to a flower.

Just as a flower is considered to lose its beauty when it loses its petals or it falls off or fades or dries up, so does a woman lose her attractiveness. But, even then the flower is useful at that time, just like a woman.

Just as a butterfly is attracted to a beautiful flower, so is a man towards a woman. Butterflies are often given a masculine gender because they flutter from flower to flower. The essence of a flower's beauty or a woman's beauty is enough to take anyone's breath away. But no one bothers to look for the inner strength that is the real beauty.

A woman is loved and adored as long as she is able to serve the purpose; so is a flower. Both can bring a feeling of exhilaration and awe. Man thrives on the very existence of flowers with or without the awareness of its characteristics and traits which are similar to that of a woman. Though a woman has many parts that a flower does not have, they have the body and soul of a flower. The honey or nectar could be their lusty essence of womanhood. But sometimes, a woman floats into nothingness.

I was not bothered about losing the most-sought-after 'part' of femininity, even though I had already lost another vital attribute part of womanhood, one that makes you a proud mother.

It is a trauma to lose it suddenly, and at an age when you are not old enough to lose it. The after-effects of not producing vital 'feminine' hormones, the psychological changes a woman goes through due to sudden menopausal symptoms, a lack of understanding --- everything is sometimes a slap on the face of womanhood.

I am a rebel and a strong believer of keeping up the dignity of woman. A slighting word from anyone was like taking the wrath of a rebel in every way. I was a person who grew up hating the perverted and selfish ways of men (though I don't measure all with the same yardstick because I find women too of the same category).

A woman can be the most passionate person. But she can also become tight-lipped and non-expressive in an extended family. From being someone who was very expressive and straightforward, it was a great change to become a person who buried everything in the remote recesses of her mind --- a person who has passionately given her everything for the family that was her world --- it was nothing less than trauma that affected the heart, body and soul to lose her feminine parts.

Being born the fighter she was, she turned to the things that meant a lot to her. First time she lost her vital femininity, she went back to teaching tiny tots who captivated her heart. When her world crashed again with the loss of all her remaining 'feminism', she took to reading that used to be her world, and slowly she took to writing her thoughts, a habit her dad had inculcated in her as a child.

I am still passionate, beautiful and the same person I used to be. I learnt that passion and unfeigned love never dies. I love cancer for what it has done for me --- to be my old expressive self, writing my innermost thoughts, which perhaps someday someone might read and figure out that inside the fighter, there still lives a vulnerable person who is ever passionate and ever loving.

> A beautiful bud bloomed,
> When a butterfly softly touched,
> She slowly unfolded her petals,
> Singing the most melodious tune,
> She had in her rejoicing heart.
> A waft of misty enchantment,
> Created a magic in the air,
> As the butterfly kissed her,
> She danced in the gentle breeze
> Flashing the most beautiful smile,
> With a mischievous twinkle in her eyes,
> Feeling happy to have
> Endured the pain of a bud
> Blossoming into a delicate beauty,
> She spread her sweet fragrance
> Knowing well she had to join
> A carpet of flowers, in its bower.

6

Rise and Shine

Early risers understand the meaning of "rise and shine" because they know how blissful dawn can be, ushering in beautiful mornings. The first rays of sun gently caress you like a mother waking up her baby, the soul awakening from a deep slumber. There is a flurry of activity as the birds keep chirping enthusiastically, singing the soul's song.

Basking in the sun's early rays as they fall on your face creates magical warmth in your heart. You feel wonderful as you walk briskly in the open, gentle morning with the breeze kissing your face and bringing in an inspiring enthusiasm of a child.

When you wake up in the morning with a yawn, think of grabbing a few more winks, there is a feeling that you are missing out on a lot. Going through chemotherapy made me reminisce about the early morning walks I used to have, breathing in the cool crispy misty breeze.

I wished I could just get up and go out in the open to breathe that fresh morning air. I used to think of this quote: "Your attitude in the morning reflects your personality. You can either wake up grumpily or with a smile. You can choose to whine or hum a tune or wake up to see every day, presenting a host of joys and miracles."

I always used to marvel at the rising sun on my way to school early morning, enjoying the cool breeze that caresses me, greeting the warm rays of the sun with a smile and a bounce in my heart. Chemo left me with no energy for the first week; still I had the bounce in my heart to wake up with a beaming smile to fight away my blues. It is said, "If you have joy in your heart, no mountain will be too high to scale and no ocean will be so deep to explore."

Both these suppositions have always kept me in awe.

Cancer woke up,
The passionate wanderer,
One with nature's beauty from,
A deep well of silence.

It whispered to me,
The value of time,
To a nostalgia of,
Embracing each season.

In an endless sea,
Of eternal harmony,
To gather my smiles,
Like a fragrant flower.

In the breath of dusk,
To look at hues of dawn,
And persevere the falling,
Through endless skies.

7

The Chemotherapy of Life

Cancer is taboo for many because of its treatment. No one sees the 'can' in cancer. It is like falling into a chasm and then emerging from it with a will to fight; to reflect upon your journey through it and feel happy that at last you emerged a winner and not a victim. Although it was not new to me as I had seen my close ones go through it and been a caretaker, it was a different experience altogether going through it myself. Though I felt unwell for some time, I recovered between the different cycles.

Chemotherapy is the use of medicines to kill cancer cells that mutate fast. Powerful drugs are circulated through your bloodstream to destroy the growing cancer cells. They are supposed to harm the healthy cells, too. My first cycle of chemotherapy, my oncologist --- an ever-smiling doctor that I have ever seen --- explained to me how it is given: the number of cycles, the after-effects and the care to be taken after and during the process. It is administered depending on the type of cancer and its stage.

I wrote this after my fourth cycle of chemo:

When the IV set was set, I was prepared to experience the worst, as I had seen my sister's plight years ago. For me it was one cycle every three weeks. After the first chemo I got mouth sores, my taste buds just disappeared, I felt washed out for one

week, sometimes diarrhoea other times constipation --- it was all new for me.

It triggered my dormant piles to a state of bleeding because of the constipation. My diet was turned to a trial-and-error food chart to see what suited and what didn't.

By the third week, hair started coming out in my hand in tufts. I laughed over it. I was able to tolerate everything including the trauma of feeling helpless to do anything at that point of time. I took to reading and listening to music. I jotted down my feelings and experience in form of notes and verses. On one hand, there was the pain of mastectomy, on the other the lethargic feeling the chemo gave me.

After my second chemo, on my way home, I went and shaved my head. My friend who came to meet me that day said it suited me and my face glowed and a saffron robe would be an added beauty to it.

One morning after I got up, I felt very uneasy and thought of lying down. I thought, my family would get worried, so I started walking towards my bedroom but landed up against a wall in the drawing room, and passed out.

Another day as I was talking and laughing, I ended up crying. And I realised, though these ups and downs are there emotionally, it is all in the mind to fight the blues. Tiredness, fall of blood count and lack of sleep were some of the things I felt, but not difficult to cope.

Music is the best therapist. And so is taking up once again all that I had once wanted to do but couldn't find the time for. These did help me to get back on my feet. Sometimes I felt so lonely that I wanted to cry my heart out, but I fought my blues away with the music I loved so much. I used to jokingly say that if I bite the venom would come out like a snake bite. I didn't fight my tiredness, instead I pampered myself by taking ample rest.

How you feel depends on individual person. I took to music, reading and writing to fight my cancer and feel good. It does help to write what you feel. You feel lighter jotting down your feelings. You can do what you love to do and something that makes you happy.

A fire of passion,
Burns inside me,
Eyes twinkle in mischief,
Lips long to explore,
The land of unknown.

Heart pounds within,
As the lost soul,
Awakens to love,
From pain to delight,
With an exuberance.

The pulse of passion,
Accelerates a longing,
To fall deeper into a chasm,
Flames a fire
In my soul.

Lost in those memories
Of total submission
I plunge deeper into
The fire of passion
The venom brought out.

8

Life is Beautiful, With a Beautiful Pain

Life is beautiful, though it comes with a lot of challenges and obstacles. The beauty is in facing them with courage and allowing them to have a calming effect, and act like a balm; enduring all pains during trying times with faith and hope.

Life is full of beautiful moments laced with joy, passion, success and comforts; these moments are punctuated by pain, sorrow and failures. You will never realise the beauty of life until you really start to live --- a life that combines tragedy with splendour; a life that shows that even a tragedy reflects something engaging and challenging.

There is no doubt that life is a celebration of every moment; and facing the unknown in adversity is challenging. One who has not gone through difficulties will never know life's worth or know the joy of overcoming those difficulties. Challenges are a test of your courage, patience, perseverance and determination; and they bring out the true character of a person.

It is these adversities that strengthen the will to fight all battles of life. It is only when you toil and sweat, your soul nourishes and sustains.

Life is a bed of roses --- only if you admire and endure the thorns, without whining and seeking sympathy. It is only then you see the beauty of life, of living and of being alive. The thorns remind you of the pains and roses the joy. If you face the challenges and pains with courage, then you know real contentment, otherwise you are disillusioned and ever disheartened.

Even when the pain becomes a constant for me, I find beauty around me. This pain is what keeps me grounded and humane. I consider even the pain beautiful; as it tells me I am alive and lively. To put it in a nutshell, life is always beautiful; and like the roses it has the challenges of the thorns that have to be faced with a never-give-up attitude.

> Life tingles through me
> In every little cell,
> Even with the venom,
> That spreads through me.
>
> An absolute immersion,
> Blankets every little thought,
> Driving the invader
> With a hopeful belief.
>
> It spreads like a fire,
> Of passionate moments,
> Cools down as it comes,
> And exhales in constant repetition.
>
> An unrivalled beauty,
> Channelling invincibility,
> With pleasant smiles,
> Of a unique vision in my soul.

9

A Bare Tree

The silhouette of a bare tree, bereft of even its branches, on the bridge over the Adyar river had always caught my attention. I always used to observe that tree whenever I passed that way. I really admired that small tree. It stood tall and strong, knowing that spring might not clothe it in green, yet majestic and useful. It may have used up all its energy and bared itself; but seemed like it always knew it was still full of beauty.

Another tree that has me in its awe is the Gulmohar tree --- known as the "Flame of the Forest" --- in my compound and neighbourhood. A deciduous evergreen tree standing beautiful with its green leaves and red blossoms, its branches spread wide and forming an umbrella like canopy. When its leaves fall, the beautiful tree bares itself with only its fruit hanging. Trees have been a companion from my childhood, but today when the cancer robbed me of my feminine parts, I see a bare tree and understand the significance of it. It tells me its story of survival against tough weather and changing seasons. They wait for the spring to fill them with green foliage.

"Beauty lies in the eyes of the beholder" --- a quote I love because, for me, even the barren tree looks as beautiful as it was when it was lush green. A different kind of beauty that is elegant yet very strong. Though they look thin and frail,

they bounce back to life when spring comes. What makes the barrenness beautiful could be watching the leaves and flowers slide down in the wind to make a carpet below, or is it the warmth and happiness they give?

I think of my journey through cancer and the treatment when I see these bare trees. The barrenness reminds me of my hair loss and the shaving of my head, and still feeling beautiful and strong as ever. Loss of hair never meant anything to me, because I knew like the tree I, too, would get my hair back once the chemotherapy is over. It was neither my actual identity nor a loss. It is important how you fight it out and live your life to its fullest.

Like a bare tree returning to its greenery in spring, I, too, bounced back in spite of my losses. Chemo brought out the nature lover in me. For me, that was becoming one with the beauty of nature and its wonders. The bald head and barrenness proves one beautiful thing --- life goes on and on and I keep fighting for my life. The buds of spring entered my life in all its splendour. I learnt that bare trees represent beauty and life. Life goes on as it ever does. I got back the 'me' who loved everything in nature. I had been a person who, in the rat race of life, had no time to stop and enjoy the beauty of nature that I used to love and adore in my childhood.

It was a magical awakening. The trauma of cancer drains you emotionally, mentally and physically --- if you let it victimise you. Writing about my thoughts and feelings at that period was a blessing, a way of expressing all my emotions and that helped me stand up tall.

It was a way of challenging me. Through the barrenness, the roots of beauty and the marvels of passion etched a lot of lines in the core of my soul. Inside me is still the beauty of the mist of love, with words of silence and rain, the beauty of the beating heart of the sky, magical falling leaves and flowers

dancing as they fall, passing through passion of fire, pain and love, with the strength of a tree.

"A tree bereft of,
Its branches and leaves,
That still stands tall,
Instils hope and inspires.

It stirs my heart and soul,
With an unfeigned love,
And undying passion,
That's a treasure in me.

It reminds me of beauty,
In the twinkling eyes,
To bloom like a bud,
And tantalise my soul.

It ignites a flame,
In my awakened heart,
To keep passionate love,
Burning fiercely forever.

10

My love story with the creeping crab

As I look back on my journey of life, I realise that in May 2014, I celebrate my cancer anniversary (Cancerversary). It marks my survival despite the pain, pokes, discomforts, transformations and transmutations. The completion of a difficult yet important phase of life that was absolutely meaningful.

Though I knew about the traumatic nature of the creeping crab, I chose to look at it as a journey of love, making use of all the tools to keep me positive. I never wanted to use the terms 'poison' or 'deadly' and chose to take all the procedures and treatment as a learning process and as a light of love.

I considered it a gift to make a deep connection with myself and to value life; the spirit that took hold of me in a positive way. There started my love story with the creeping crab that came in the form of breast cancer.

My only aim in life became to capture the essence of any given moment, and make it a significant milestone of life. Even after all the chemotherapies and radiations, the creeping crab was reluctant to leave me. It was all set to invade my tissues time and again, in the form of the suspicious looking atypical cells which tend to act like cancerous cells. I felt that the

creeping crab was madly in love with my body, but the fighter in me was not willing to budge a wee bit. It sounds cruel and crude, but it is an ironical truth.

After two years of the love journey, it came back yet again threatening to seek vengeance. When I was being stripped down to the layers of tissues physically, I realised the validity of my spirits that made me positive and felt very tender and joyful. For the first time, I started loving the cancer. It made me what I am today --- stronger and with more courage. I knew that I was embracing the unknown, accepting the unbelievable and then celebrating all the milestones --- of all the surgeries, the scans and the scars.

Sometimes life is all about taking a deep breath and pausing; then listening. It means continuing with courage, with renewed strength by nourishing and taking care of oneself.

It also made me value life and feel a kind of gratitude towards cancer, for allowing myself to shine and celebrate myself. The residuals, moments of recurrences, FNACs, the threat of atypical cells and the whole process marks the cancer anniversary as the ultimate and unique love story of my life --- that with myself and cancer. It is always a bitter-sweet plot of life's journey.

Like many other love stories, my journey with cancer started in a fight and ended up falling in love with it --- for what it made me realise: the importance of life, relationships, family and my priorities in life. I was thrown headfirst into the world of cancer and I accepted it with grace and courage.

It is a love story, simply because something beautiful emerged out of that struggle: I wanted to survive, grow and shine with a positive radiance. I believe every person touched by cancer will have a story to narrate.

Today, after going through a second mastectomy, I feel that the creeping crab did make a drastic change in me, making me always positive, grabbing the odds and hurling them back to say "try me" again. It is a story of fear for some, but for some it is a love story, that made them survive against all odds. Though it does try to scare with suspicious looking cells, the fighter in me is prepared for anything. A veteran, as I am jokingly called, gives it a tough time, instead of it giving me scary days.

Isn't my love story interesting? After going through so much pain, the scars, the bruises, and all the trials, I still feel, "Wow, I made it out fighting." I feel triumphant that I made it with a smile. They say the scarred tissues are much stronger than the regular tissues. It may be an after-effect of the strong willed perseverance.

The creeping crab does make you realise what loss is, makes you fight and find your way out from the depths of despair. You learn to appreciate life and that understanding fills you with an empathy; a deeper concern for the value of life.

It is when your very life is threatened, you realise the value of being alive and each day you wake up thinking it to be a blessing. It is then that you look at the small things that give you joy and count the little blessings being sent your way. It teaches you to believe in that which can cure the briefness of life, for there is no remedy for mortality.

You learn to continue your belief in your doctors, the treatment, decisions; and most importantly yourself and your strength to endure. You learn to appreciate and enjoy every single day fighting all the negatives to stay positive.

I was a rebel, am a rebel and will continue being a rebel. And cancer made me stay a rebel forever. As Jim Valvano quotes: "Cancer can take away all my physical abilities. It

cannot touch my mind, it cannot touch my heart, and it cannot touch my soul."

I am a born fighter and will remain one against all odds.

Touch as soft as feather,
Whispers of love,
Gasps of giving,
Passions aflame.

Words unspoken,
No lies untied,
Not looking back,
Passion fuels fire.

Longing for an embrace,
When time is precious,
Vowing to the other,
Of a love forever.

Tomorrow is unknown,
When cancer mutates,
Life is threatened,
Only memories remain.

11

I dare to bear ...
The multifaceted pain

"Always rely on a happy mind alone ... A controlled mind will remain calm and happy no matter what the conditions."

This quote made me think of the pain and challenges in my life. The way to embrace pain is by not giving in to it but by fighting and enduring it with a strong will. For the first time after so many surgeries, I complained of pain to the doctor. I found myself asking if it was the age or my endurance that was the culprit. I found my family doctor --- who has seen my journey as a friend, confidante and doctor --- smiling at my question.

Physical pain has to be endured and fought with; at least that is what fifty five years of experience with pain taught me. And the last thing I would do is rant and rave about it. Sometimes even when you find others rejoicing at your pain, I dare to smile in that pain. Knowing that, I accepted this pain with deliberate intention when I could have avoided it.

When I spend entire days and nights trying to do things that make me happy, I find the pain taking an upper hand and even my smiles show that. But the fighter in me is not one to

give in to the pain. I decided to fight it out with my words, a smiley stress ball, making my fingers crawl on the wall and counting on my fingers.

It sounds childish. But I enjoy it. These are exercises for my hand and fingers that I do throughout the day to keep myself occupied and to recuperate my arm that has been robbed of its lymph nodes. So I told my pain to hang on, because I know that it is this very biological function that makes us thrive and survive. It is also the alarm bell that warns.

It is easy to give in, to be defeated and become a victim ... which is like suicide. But I dare to bear ... and bare ... the pain as a warrior. Life is beautiful for only those who know how to celebrate the pain. Enjoy this time; every moment is precious in life.

As Norbet Platt quotes: "The act of putting pen to paper encourages pause for thoughts, this in turn makes us think deeply about life, which helps us regain our equilibrium."

Pain rained on my body,
Like a river in spate,
After ages of turmoil,
Battered by the crab,
In icy deluge,
Midst a sea of beautiful pain,
A bustle and confusion,
That threatened to engulf me,
Turbulent storm of rapid thoughts,
Trapped in the poison of chemotherapy,
The mind won over the body,
With a rainbow in the heart and soul,
The pain brought in my life.

12

Smile of a lost soul

"A smile that struggles through tears is the most beautiful."

Smile away the cancer in you; kill it with your positive smile. Cancer is neither a disease nor an illness; it is a gift to help you value life and wake up every day feeling happy for being given another chance to do all the little things you wanted to do and that meant a lot to you.

It is a gift to find within you the lost self that you neglected in the day-to-day struggles of life. Cancer can be your passport to enjoy life the way you want, enjoying every bit of it for the entire trauma you went through and came out with a winner's smile.

Inspirational quotes that I read somewhere: "Don't cry over anything that can't cry over you", "When life hands out lemons, squeeze out a smile", are what come to my mind. The mammogram, needle biopsy, diagnosis, mastectomy along with removal of lymph nodes, the chemotherapy and radiations --- everything was an experience of going through a long unending tunnel and then emerging into the light with the brightest smile of having won, rather than becoming a victim.

In fact, there is no kind of problem or obstacle for which positive thinking or a positive attitude has not had an

upper hand to fight the "emperor of malady" away. A grin is perpetually like a flashing neon light.

I have come a long way unburdening myself, and the cancer seems to be in love with me, it keeps coming back and I keep fighting it off. But I can smile it off and be thankful that I got back the soul I had lost while I slogged through life.

I had forgotten that I, too, had a soul that needed to be taken care of. I found I could still flash the most beautiful smile even through my tears.

I was not perturbed knowing I had a malignant tumour. I had prepared myself for the worst so that I could smile before my family to give them the assurance that all is well and that I would be back and up like before.

Though cancer had killed my sister and mother-in-law, I was ready to give it a fight that it would not dare to come back. But that attitude, I think, made the cancer fall in love with me to return. I was determined to love it and send it away with the toughest fight I could ever give.

> Just like anyone else,
> I wake up every day,
> With a beautiful pain,
> Of a lost soul.
>
> Dreams of being loved,
> With a passion,
> That can hold my breath,
> And a fire burning deep inside me.
>
> I find a smile in my soul,
> Close my eyes and rest,
> With the comfort of,
> Having found my old 'self' again.

I know the pain of,
Going through all,
That made me bare,
Still passion burns in me.

13

The sparkling beauty in the jewels of nature

I love the little things one hardly pays any attention to; something new and beautiful about the tiny things that are considered ordinary by many.

I love the raindrops because they are refreshing and rejuvenating. They are tiny entities of beauty that are clean, pure and make you feel one with nature. Raindrops are like jewels gifted by nature. A raindrop can be seen in many ways. To feel the raindrops falling on the face is pure ecstasy. They bring a fresh lease of life, reflecting everything around like a tiny mirror and in spite of their vulnerability to even a gentle shake; they never ever cease to inspire me. The raindrops are pristine reflections of life itself.

Raindrops are magical and inspiring, like precious jewels that disappear in a flicker or linger on creating the most beautiful ornaments on the trees. It is a magical experience to just roam around watching raindrops on every leaf tip and flower: nature's way of hanging ornaments on trees. When the sun comes out, it sparkles on millions of raindrops, making it seem like millions of diamonds and they glitter like gems in the night, reflecting the light around.

You are truly blessed if you can see the beauty of the raindrops, the way they hit, roll off or hang on. Each raindrop on trees, leaves, flowers, blades of grass, seems to tell a story. They are tiny entities of nature that remind you of the beauty of life. They are the most beautiful gifts of nature.

Raindrops that fall down from the clouds in its brief journey give a trillion reflections of the core of life. They then turn into a puddle and reflect the world around intricately and delicately, focusing on all that is around it.

Every raindrop has music in it, dancing to the rhythm of the wind. It gives life to everything and creates different sounds and music as they fall on various things. As it falls and hangs on to the leaves of a tree it seems to whisper, dance and make ripples in the puddle. Life, too, is just like being a raindrop; knowing it is just fine with having ups and downs and continuing its journey as it stretches and breathes.

A raindrop like life, in all its beauty, clears its obstacles and struggles, and makes its way slowly to its final destination, inspiring, giving hope and joy.

A raindrop is like a drifting soul, its life temporary and unpredictable, not knowing where it will land but still happily going on, joined by many more such tiny reflecting mirrors, and bringing beauty, joy and hope.

Life is also ever-changing like the falling raindrop. Sometimes it lasts forever and then suddenly it disappears. It soothes as it falls, few love them while some hate them, but it falls irrespective of everything and heals the soul. It is an ever-searching soul. These raindrops make memories that pave way to beautiful sunshine of a tomorrow.

The plummeting raindrops gleefully dance into a rhythm of motion like lost souls and splash to the ground. A zillion drops move as if in trance of the rhythmic dance, few miss the beat and drop, splashing to the ground to form puddles.

It is such a beautiful and awe-inspiring feeling of life to feel a raindrop on your fingertip: A bubble reflecting life, giving hope that challenges don't linger and that life keeps shifting. The raindrop has no control over where it falls or the patterns it makes, but the tiny drop brings life and hope to many. It is more than just hope; it is a promise of a rainbow in life.

The unique sound it makes and the upside down reflections of the world is a miraculous effect of life lulled into a sense of completion. The raindrops glistening on the trees, the palette of the beautiful sky preparing to make a breathtaking rainbow and the thrilling twitter of drenched birds as they celebrate life is an amazing sight for me, watching yet another facet of the beauty of nature. It soothes and heals the pain in my body and soul.

Raindrops fall onto trees,
Speak for it,
Reflect the world around,
And hang on its journey.

Listen to the raindrops sing,
In solitude of nature,
Simply unwind,
To traverse around.

Raindrops on the tip of tiny leaves,
Catch the sun's rays,
Shine like diamonds,
Though fickle its life is.

A gentle breeze playfully shakes the leaf,
It lets go of the leaf,
Down it splashes into a puddle,
To become one with the whole.

14

In the core of a heart is its most puzzling ways

'Home is where the heart is', is heard commonly. That is because the most important of all your body organs is the heart; the exact home of your body. One that is always abused the most. It is never taken care of until it is too late and gives a warning in the form of a block, a thickening or a fast beat.

It is a well known fact that the heart affects mental clarity, creativity, emotional balance and personal effectiveness. The heart and mind are always at loggerheads. The stress and strain of day-to-day life, too, is an important factor. Your heart is responsible for just about everything that gives your body life.

"If you think with your head the heart is just an organ that pumps blood. But if you think with your heart, you know that it is the core of human existence. A heart feels, emotes and expresses. Often a heart is given more importance than the brain. The heart is the most symbolic part of your body. Logic says it is better to think with both your head and heart, to save the heart from the wear and tear of day to day life."

The heart is the metaphorical or the symbolic centre of emotions that include affection, love and care. The heart races because of many reasons. It races when you are in love,

when you see something alarming, when you are sick, or when someone surprises you.

There are many reasons why your heart races. But when the heart races without any reasons, it alarms you, because you don't know what is happening. Palpitations are the unpleasant sensations of irregular and forceful beating of the heart in the chest. It sometimes pounds against your ribs so much that you feel it will explode any time.

As age catches on, it is alarming to feel your heart race at such a fast pace. You get uneasy and your chest feels as if a big boulder is on it. It is very puzzling when you have to go through various tests to find the reason for your racing heart. It is sometimes a premature contraction of your heart because of irregular heartbeats. What causes it, you never know. You might feel as though the heart is fluttering, throbbing, flip-flopping, and the rhythm of the heart too fast or too slow.

You sometimes spend sleepless nights due to the unruly beating of the heart, making you wonder what could be the reason for its fast beats. The heart finds it difficult to keep pace with what the mind is battling.

You hear about the flutter in chest and stomach, which at a certain age is enjoyed. But when your heart flutters nonstop at any given time, it is time to sit up and think.

They say it is an adrenaline rush in response to a fight-or-flight situation, causing blood pressure or a racing heart. It is time to wake up to the fact that your heart is fighting hard. Just like the rhythm of life, it is vital to keep the rhythm of the heart, too.

A tired and fatigued body loses both the rhythm of life and heart. The born fighter in you fights to keep the rhythm, but at times both body and heart let you down, which makes your challenge even harder. Staying positive against all odds is the only solution. And the mind has to win against all odds and fight till your heart quietens and calms down.

"Your attitude affects your latitude", is it a cliché? Optimism and hopeful expectations does influence the health positively. The body sometimes plays havoc, in spite of the positive outlook you have towards life. It could be because the body did not recuperate properly. Rather than simply seeking positive happiness, you need to learn to create a harmonious attitude between emotions, soul, spirit and body. That needs patience, perseverance, grit and determination; to become a warrior and survivor, in spite of all the emotional and physical challenges of life.

The most beautiful music in the world is your own heartbeat because it assures you that you have survived all the battles of life, even when you are fighting a lone battle with your pains, or when your body refuses to recuperate and sometimes retaliate.

You fall in love with your own heartbeats when it races in such a way that it threatens to run out your life. While the mind fights, the heart races at its own accord. I sometimes wonder what a heart, the largest muscle in your body, could do to the core of your life as the mind fights all the battles of life with a smile.

"Deep inside my heart,
In the ante chambers,
It is on a rampage,
As if it would explode.

My heart flutters,
It races rapidly,
With spasms of pain,
And shortness of breath.

Unknown are reasons,
Squeezing my heart,
It beats musically,
And knocks its walls."

15

Living life beyond cancer with love

Turning the negatives into positives is the greatest challenge of life. It is a challenging life to live with the threat of triple negative breast cancer. Surviving it with hope, converting all the pains and fights into a celebration of life itself, makes you value life and enjoy every moment. It is a great achievement to survive and celebrate all your pains with a smile.

Dealing with cancer is the greatest challenge, that goes on for quite some time, especially for those who carry the abnormal, inherited breast cancer susceptible 'gene' because they tend to recur, and are more prone to its frequent attack. Breast cancer is in fact a family of diseases, some aggressive, some advanced and some deadly, but the 'can' in cancer beats all if you have the will to fight.

Each person has a way of dealing with the threat of cancer, just like no two persons are the same, the dealing with it, too, differs.

Cancer changes your life, often for the better. In any illness, the most important thing is never to lose heart. You need to be cheerful and positive, to support not only your mind but the body also. Many experience significant emotional and physical changes. While few see a hopeless end to life, others see a

rainbow of hope. Life is mostly focusing on the challenges, rather than the fright it may give.

Cancer is a life-changing obstacle that can be overcome with perseverance and courage. You have to be constantly vigilant for signs of any recurrence, without really being anxious over some of the physical changes and by listening to your body.

Walking and breathing helps you to learn a wonderful way of being a survivor. Everyone's journey through cancer is unique and knowing that others, too, have gone through the same can give strength and inspiration to keep everything in perspective.

When something happens in your life, you can let it define you, destroy you, strengthen you or wallow in self pity. Life is always a beautiful struggle when you know how to celebrate pain. Cancer makes you realise that the most beautiful music is that of your heartbeats, because it gives you an assurance of your survival against all odds. The key to your survival and improving the quality of your life is to understand 'cancer'.

Cancer is not a death sentence, although it seems like that to many. It does not stop your world or your life; no disease can do it. You have the choice to turn it around so that it is a new learning experience to overcome and take charge of your body by not becoming a victim.

Cancer treatment does put you into a thought process when you start wondering what's happening inside you. There are times you start laughing over things and then end up in tears without even knowing it or wanting it --- a total confusion of your emotions. It is up to you to overcome it with a positive feeling that nothing can ever touch you. It is a confidence that everything is just fine and the best feeling is when you get out of that 'rock bottom' state.

Cancer teaches you to live beyond it by looking at life differently, to do things that you have been yearning, visit places that you may have dreamed of, fulfilment of a dream and most importantly to stay positive always. It is exciting to think about it, but you need others to understand what you have gone through and your fight against cancer.

The understanding does help you fight against all maladies, though it is solely your own fight for life. Sometimes you don't understand your own emotions because it is a constant struggle between your body and mind. The best solution to get out of it is to do what you have been yearning to do, something that gives you immense joy to overcome everything you are fighting out.

Recovering from an illness or a surgery is a pathway to finding your inner power and radiance. Your commitment to life depends on your own ability to digest it and how you feel waking up to a day of pain and how to relate to it. The radiance is there in you with the power to fight all challenges that come your way. You will never know the value of finding joy in little things if you have not known pain.

To put it in a nutshell, you have to experience a blend of pain and joy to know the real value of life. More than the journey through cancer I look forward to a life beyond cancer with a positive radiance. Your mind can create a positive light, with a consistent and strong positive attitude.

Love and pamper yourself --- for all that you have gone through. You deserve to be happy doing the little things that mean a lot to you. There are certain things, individuals or events that have an impact and leave a mark on you in your journey through cancer. They are an outright blessing and fill us with warmth, while some are like bullets that hit the heart.

16

Some lone battles in the journey of life

Thoughts are seeds of your actions and thoughts are what make you what you are. They are simply an indication of our life on the whole, in its flow. Life is in how you stand up against adversities and face it.

It is said that if there is light in the soul, there is beauty in it. Sometimes in life's journey you have to walk it alone. It is not that your loved ones are not with you; it is because some battles in life have to be fought on your own. You have to walk it alone because only you know what it is to fight out the cells that tend to gnaw every now and then into the healthy tissues of your body. In a fight about life, no matter what it hands you out of the blue; you need to be strong and face it head on.

When life gifted me with a triple negative cancer, I was prepared to face the recurrences and fight it out with a never-give-up attitude. At times the body does become weak, making you quite vulnerable. It is a long emotional fight with your own self. If you let that feeling take an upper hand, then it victimises you. It is a lone battle that you have to fight on your own.

Instead of becoming a victim of the pain, win it over and live a life of a legacy. It may mean fighting with your mind

and body, but if there is an inner drive in you to fight it out against all odds, then half your battle is won. It is not a fantasy of life but a stark reality. In life's journey your true courage and personality come out when you have nothing to lose; and your only choice is to face the situation with a smile. There is a 'can' in cancer, because you can beat it.

I read somewhere, "When you are down and out remember this: That the sun rises for you to give you light, the trees take in your carbon dioxide just so they can give you oxygen and the rain falls to cool you down. Why give up when nature has faith in you?"

How true it is. Why give up just like that when the actual power lies within you to heal yourself with your inner strength? Why stress yourself? Why let others stress you out? Adversities make you strong; it is the journey of the unknown which gives you real strength and the will to face any challenge in life.

It is that positive drive in you which weakens even the cells that come to invade the very core of your life. When you are in a lone battle with the creeping crab, it is a life of constant learning, a constant fight with the one which has come to hack your life.

Life sometimes turns out to be different and also cruel. It may not be things that you wanted to happen. But from that life, too, you can gain everything you want instead of wallowing in self pity. There is a positive side of learning from whatever you may go through in life.

You can find happiness and peace in many ways, in spite of what you are going through, that even destiny itself cannot explain. You can find joy in many things, even when you are constantly fighting pain. Your fight with the unknown ways of cancer shows you how precious and fragile life is. It is like vapour: here today, but gone tomorrow. As long as you are alive, live life fully without moaning about everything.

The wear and tear of your system, sometimes hands you several problems. Though a human body has its own defence mechanism, time and again you end up going through a lot of surgeries and post-operative pains. Every organ of your body is sometimes threatened in more than one way. The biggest and unknown battle is the invasion of cancer cells in your body.

The trauma of the surgery, the after-effects and the pain is like a non-ending battle that you have to fight alone. No one knows what you are going through, hence a lone battle that is fought with your own body both physically and psychologically. The minute you give in to the pain, your battle is lost forever. You have to fight it out every living moment of your life.

But at the end of that long tunnel of trauma, when you come out victorious with a smile, you feel that it was worth putting up with all the pains. It is a lone battle that you fought with yourself; you endured all the physical pain and the psychological power to heal yourself was within you in spite of all the challenges.

Never let life during any illness make you regret about the life you lived before that; let it be a dream about the life you will live after you have conquered it.

I prefer to live a full life, even when my life is a roller coaster ride with lots of ups and downs, twists and turns, not knowing the speed or what's next: a drop, a sudden turn or a climb over a steep hill. I choose to live without fear, allowing my life to open with an inner power and strength to be a glowing torch, always lighting a fire in the heart to face the unknown with courage and patience.

Life always kept me on my toes: it hit me with something unexpected, sometimes an emotion, a bruise, a scar and always many challenges. It is that real life experiences which made

me what I am today. It is the mental attitude that makes or breaks life.

Never rent life from others. Fight your own battles, even if you have to fight it alone. Walk the journey of life with courage; breathe with a strong will and determination on your own. Let your grit and perseverance propel you forward in life. Face everything with hope and courage, challenge it till it leaves you, lift your spirits when you feel weak and soar high with all your strength and life's energy.

I am thankful for the little mercies God bestows on me, in everything I go through. I find immense joy in little things around me. Being a born fighter, I don't like to give in to any pain; so I fight it out daily just because it makes me lively and energetic. Life taught me from a very young age to fight my own battles and be my own fortress and power of strength.

Why cancer cells invade my body time and again is still an unknown truth --- maybe it is genetic. Even doctors don't have an answer. The unknown has forever intrigued me and never created a fear in me. I have learned one fact of life: never give in.

In spite of all these battles, I know one day I have to go away from this world. But I will be happy to have fought all my battles as a warrior and never a victim. Life is always beautiful and it is this belief that keeps me going.

I was, am and will be a tower of strength to my loved ones. I know that I would always be that glowing ember, the one smouldering forever, even in the ashes.

In touch with my inner self,
Emotions of loving and being loved,
Spanning from admiration & adulation,
Reflecting diversity of love.
Speaking in volumes,

A gentle whispering,
Can calm the mind,
Like a raging sea,
I flap my wings to soar.
Feeling elated and enamoured,
With heart and soul,
Having made me whole,
Unfeigned love and passion,
Where trust and belief never lies,
My life companion,
Words have no end,
For making me complete,
Though I cease to be now.

17

When pain rains in your life, you realise the value of life itself

It is an irony of life that sometimes you realise the importance of pampering yourself for all the sacrifices made in life and all the pains endured when it is rather too late to mend the overworked body. Still, it gives a sense of satisfaction that the mind, soul and body, was used, misused and abused, at times, for the welfare and happiness of the loved ones.

When you are on a journey of accommodating others and neglecting the redressing of your own needs, then the body revolts on its own before you could even realise it. It is then that a revolution of "you" challenges you to look at it with a different perspective. Anything and everything needs to balance itself --- to walk the tight rope of life --- be it even your own self.

Life is worth more than feeling inadequate or wallowing in self-pity looking for a shoulder to cry on. It is the pain that makes you realise that life is the most valuable commodity. A life is never dependent on another. It is an entity by itself. The psychological, emotional and physical pain, all these depend only on one person and that is "YOU".

It is a very late realization that a person comes all alone to this world and you have only yourself to heal, inspire, motivate and rejuvenate. Every person is lonely, even when many loved ones are around you. Only you can heal your own pains and it is foolishness to look forward for emotional empathy. The day this realization comes, you are at peace with yourself.

The best healer of any pain is the nature surrounding you. A lover of nature always, I realised its impact and healing capacity on me, after the creeping crab invaded my body. The magical sunset, the sky, the clouds, river, sea, mountains, trees, rains and cloudy skies --- everything around me brought happiness and I considered them as little blessings sent my way.

I found a childish joy in getting drenched in the rain, allowing the raindrops to fall on my face to heal me. I felt a kind of childish excitement while digging my toes into the sand when the playful waves caressed my feet. It was like feeling energised to the core when I could breathe in a whiff of the fresh misty air on the top of the mountains.

The first time I was robbed of an organ, making me less feminine in appearance, I had not known what was in store for me --- neither the pain nor the trauma. Living through it was nothing short of a penance of life. Even after coming out of that which seemed a never-ending tunnel, I still had a sword hanging over my head in the form of another lump.

The born fighter in me fought against all odds. I always felt it is these challenges and pains that kept me alive, taught me the value of my life.

When life gave me the creeping crab as company --- the triple negative one that was the most aggressive form --- I had prepared myself for a long battle. Today, I have become a veteran in the eyes of my loved ones and my doctors, who helped me, fight my battle. But it was really me who was the

one battling through the entire trauma; who endured through sheer grit and courage.

When my lump became too painful, the oozing fluid and blood landed me yet again in the most 'sophisticated' cave. I had to start my battle once again. When lumpectomy was suggested, I opted for mastectomy knowing very well what was in store for me. I wanted the removal of that which threatened me with cancer's invasion. Pain rained on me, but I realised the value of "life".

It was then that I realised how we take life for granted. How we hesitate to take the right decisions of life, letting the heart rule over the mind. Life is always a battle between the mind and heart. I rebel and question with my mind, all that the heart tries to dictate. You suffer silently for those who can uproot the very foundation of life, neglecting your loved ones. If I wanted to be happy, it depended solely on me.

"Every man walks a lonely path in the journey of life, as you have only yourself in life and nobody else. All those who are with you are your co-passengers who go off, when they reach their destination. You are your own sole companion, solace, healer, inspiration and rejuvenation."

I am just like anyone else; a normal human being. But I am a fighter. I am a strong fortress of strength, courage and positive attitude. Like anything in this life, the seasons do threaten to weaken it time and again. I try and garnish them with the natural ingredients to see that it doesn't crumble or wither away. My biggest asset is my "Never Give Up" stand that I have taken all my life that had always been a long winding path with lots of hairpin bends.

"Even when pain lashes out at me testing my patience and fortitude, I dare to burn, even when I turn to ashes."

A magical drop on a blossom,
Unique and beautiful,
Singing a song of love,
Making her glow majestically,
Releasing honey drops.

Unravelling her inner beauty,
That conceals her disfigured self,
Enduring all the pain,
Raining on her body,
Healing all scars.

That fate gifted her,
Unwavering about loss
Her old exuberant self,
The once lost soul,
Resurfacing again.

18

A wishful dream even when pain rained on me

Our dreams are usually a combination of verbal, visual and emotional stimuli. It is a series of thoughts, images, sensations or cherished aspirations. I don't remember any beautiful dream, but I can think of the nightmares that haunt me; nightmares of an impending illness or trouble either for my loved ones or for myself. It is like a premonition that something unpleasant is on its way and warns to be prepared for it. It may be an omen or an insight depending on what each one believes.

A dream may be something to look beyond the obvious. But a beautiful dream when the body is in excruciating pain, making you toss and turn in bed before you finally slip into a deep slumber, is like a coolant over you. In my dream I found myself travelling in a train that looked like home on wheels through a picturesque terrain. I found myself holding my breath at the beauty of nature, the hypnotic effect it had on me who was writhing in pain. It was the beauty of the day, the land through which I was travelling that held me in awe.

What was striking was that impression of elusive beauty: with misty clouds travelling alongside making you feel happy and as if you have heard the melodious songs of all the beautiful

birds before; the sun playing hide and seek showing me the powerful rays popping in through the clouds. The mountains with all the mist made me want to jump out of the train and trot to the top of the mountain and take a whiff of the fresh misty air.

When I was lost to the nature surrounding me, I heard a man calling me; he came and sat beside me asking me about my pain. He suddenly asked me, "You smile even in your pain?" Then he quizzed, "What is your only wish in such a situation?" I told him my only wish was to grow stronger even in pain. He smiled and just left saying, "So be it."

I don't know what dreams mean or the interpretations of them, but I do believe in little blessings that come my way. And I find my happiness in them. Today's pains are forgotten tomorrow, but moments of joy remain forever. I look forward to live every moment of my life fully with joy.

Let me dream once again,
How hard life is,
I feel safe in my soul,
I am only one of a kind,
Unique, a limited version,
Strong as a rock,
I feel like no one does,
A seeking soul would,
Find me in nature,
And connect to me,
Always with hope,
One moment of truth,
A choice made,
To see far and vast,
Realise a dream,

That fulfils a wish,
Happiness for another,
With powerful determination,
On my journey of life.

19

Solitude in life, to fight life

"The greatest thing in the world is to know how to belong to oneself." ~ Michel de Montaigne.

Life is fickle and unreliable; depend on yourself and repeatedly fall in love with the 'you' within. Defeating cancer and the will to win over it is in the firm determination of one's mind. To overcome the physical, emotional and psychological self-doubt during treatment needs perseverance and will power. The most important prerequisite is to relax, have a fearless mind and heal yourself.

Emotions do play a crucial role but it is your attitude towards life that helps you fight. Low immunity, the fight for life, the falling of blood count are biological mechanisms that you need to fight with a positive approach to regain your lost health, self-esteem, emotional imbalance and your physical strength.

The hardest part is healing of the self from being an emotional wreck. A sense of loneliness that creeps in during the treatment is the most difficult part that needs to be tackled first. Music becomes your therapist; pen and paper become your best friends as you put your thoughts to paper and relieve yourself of the emotions and feelings. Or pursue something that you never had time for before, or visit places you longed to visit.

It is then that your solitude becomes your best healer; solitude within nature where you listen to everything around you. It is a kind of internal loneliness that you need to fight even when all your loved ones are there to support you; it is a gnawing pain of helplessness that the creeping crab sets rolling. Just keep a never give up attitude.

Solitude can be a beautiful feeling, to rediscover the 'you' that got lost somewhere in the journey of life. It is something soothing, healing and meditative. It is the repressed feelings and memories of an unhealed wound that needs to be healed and released to become a positive thought of living for the moments that life bestows on you. Positive attitude is the key to fight cancer.

It is in solitude you find the innermost light in your soul, a beautiful connection that is powerful, vibrating, magical and real. It is a space of freedom to reflect. As a child I used to love being alone with the surroundings, a mysterious melange of colours, absorbing everything around me, allowing me to be soaked in the beauty of nature. I found that person within me again.

It is a psychological connection and communication without words, emanating mainly from your heart and soul. It is a connection with nature to listen to the silence and sounds around you as you stroll. Be it the striking rays of the sun, rustle of the leaves, tweets of the birds, the mystic mist, the blossoming of a bud, honeyed fragrance of those wild flowers that attract the butterflies or the wind whistling by.

It is a great feeling to experience the soft touch of nature in the core of your soul. I am able to perceive a situation anew by the lovely insights I get from nature as they get entangled in me. The truth and realization of those moments are interwoven in a unique and special way; of mystic reality and life's reality.

Solitude is positive and constructive unlike loneliness, a gift of spending some time alone with nature.

Solitude is a positive
Perception of being alone;
A love song I sing,
As I fall in love,
With the fearless self,
To find my lost soul,
My life's retreat,
Along a river in moonlight,
Unseen, unknown,
And not lamenting.

No emptiness, nor silence,
Content with life,
To listen and visualise,
The bliss of nature,
Within life's reflections,
Turning my soul,
Pain gnawing inside,
Healing with nature,
Not feeling boxed.

Unravelling to find myself,
Longing for solitude
For my fortitude,
With no prescription,
To medicate my body,
My racing heart,
A magical connection,
Of the moments,
That's a gift for life.

20

A resplendent magical sunset

Watching a sunset is a pleasure that soothes the mind, body, heart and soul. It is so delightful to watch the birds fly home or be perched on trees tweeting sweetly. After a few rainy days, the sunset is usually breathtaking and beautiful. When you watch something as awe-inspiring as a resplendent sunset, it soothes your eyes and fills you with an undying hope. At that moment you behold nature's art with an expression of admiration and adoration.

The sky is covered with a galore of colours, something stunning and glorious. The sunset sky is truly beautiful and striking. Mesmerizing but ominous-looking clouds gather and the sun playfully bounces them off, creating ripples of yellow and orange as the sun turns into a glowing ball of orange. The spell-binding patterns of clouds silhouetted in the sky leave me gazing at it in a childish wonder. It is the most awe-inspiring time of the day for me.

A wonderful picturesque backdrop of truly outstanding colours captivates my heart with a somersault feeling of falling in love. They never fail to inspire or heal me, spreading warmth in my soul. No sunset is the same and everyday it tells me a new story, shows another colour, shape or shadows of the day. Whatever it unfolds, it reveals its splendour and majestic beauty. It is a string of magical moments so strong

and motivating, it awakens my soul and those memories are stored in my mind like a camera, to be relived again and again.

Though the sun hides behind a tree before dipping into the horizon, it is a breathtaking sight to behold. The display of colours by nature is really astounding and the birds sing with joy. The sky lights up with bright orange and yellow, the clouds reflect hues of red with a silver lining. I am filled with a deep gratitude for having experienced these magical moments in solitude with nature, listening to the silence and sound of everything around me. In those moments, nothing else matters and I am deeply connected to nature.

There is something very solemn and rejuvenating in the splendid beauty of sunsets. The clouds glow with the sinking sun's rays. The clouds change shades, glow like a smouldering fire as the light fills the sky and slowly dim down as the twilight approaches, casting a mysterious glow over everything. The birds become still and silent, as the night sky is ushered in. The gathering dark makes everything still and silent except for the rustling sound of leaves in the night breeze.

> In the silhouette of the setting sun,
> Ablaze between clouds,
> Birds flew in tweeting,
> To quieten, my racing heart.
>
> Sun dipped behind the trees,
> Pouring hues of yellow and orange,
> My heart fluttered,
> Viewing the palette of colours.
>
> Treasured in my heart,
> Are the songs of a bird,
> Musically evocative of feelings,
> Distinctly different from all.

21

The spectacular ballet of birds in the sky

The birds flying in the evening sky creates a flutter in an already racing heart. They form such artistic patterns as they fly. These birds flying in a flock take an emergent character without any chaos in flight. They come together wheeling, turning, and sweeping in unison forming beautiful formations.

It is a photograph captured in the mind, heart and soul, like abstracts written across the sky; that of a bird, fish, heart, wave or a geometrical pattern. Just before dusk it is a breathtaking sight to behold. The mesmerizing act of birds each evening is a splendid performance of aerial manoeuvres, which occur with such spontaneity; it surprises and fills the beholder with joy.

Nature brings forth such perfect artistry; its mesmerizing beauty enthrals me. They fly in tight formations making intricate patterns with ease. My daily rendezvous with sunset has been a marvellous experience; watching these birds fly in gay abandon as they make astonishingly sharp and beautiful patterns leave me wondrous, oblivious of my surroundings. It is a spectacular display as they fly away home.

Birds' aerial formations are a feast to the eyes, as they keep changing every second. I can't help but watch them in awe.

They swirl through the sky in a magnificent ballet that seems perfectly choreographed. It is a perfect rustle of many pairs of wings, a group dance of birds that is truly an amazing sight. It is a striking ability of a flock to shift shapes as one, reflecting the genius of a collective behaviours, something very inspiring.

At first sight, it seems like an incredible moving picture hovering in the sky with their amazing and mind boggling formations. I am dumbstruck at times, watching them suddenly take flight in lovely formations. It amazes me to see their artistry in the sky when they fly across the setting sun. I am ever thankful to the cancer for bringing back my lost self who can now appreciate the extraordinary in nature.

A flock of birds,
Form a rising crescendo,
Up and down, across the sky,
At the onset of dusk.

Like a speck of dust,
To amazing formations,
In a gorgeous way,
Creating a stunning ballet.

Their artistic choreography,
Enthrals me to enslave,
My captivated heart,
With a symphonic flutter.

22

Reminiscence of passions

Age never becomes a question mark of life. Many confusions go on a rampage in the mind after a mastectomy; confusions that a woman finds it difficult to explain in words. An uncertainty of sorts goes on in the mind. Is it a woman's dilemma or a rebel's thoughts? I am unable to comprehend. As I go through the journey of cancer, I feel, for a woman, it is a blow to lose a vital part of significant beauty and an aspect of womanhood.

For those who overcome the truth of their diagnosis, loss, and battles through the side-effects of ongoing treatment, it is time for a pause. It is time for contemplation, realization and reaction. Caring for the emotional needs may not be easy and, at times, not understood by a spouse, parent, child, or even a well-meaning friend. It is a fear of denial or a gnawing question of whether the love and passions that existed before would remain the same after. It is a reminiscing of what was and the query what would be? The way your body looks and how you feel about it. There is a fear of acceptance like it used to. It is a reminiscence of bygone years, then wondering in a puzzled and haunting way of all the love in my life.

Desires are more of a mental attribute. It is acceptance of yourself and others. It is a fulfilment of life. I think every woman goes through the trauma of acceptance after cancer. It

is in the mind; it has to be squashed out and has to emerge with a smile. It is easy to feel low, in the dumps and give up. But the power lies in saying that it is not an end to life and going ahead with the beauty in your soul. The nutrition for a woman's this critical stage is to maintain loving relationships. Disseminating the fears with positive thinking is the only solution and it can only happen with the power of the mind. Drive away the fear of how your spouse would react with a positive thought that love is not physical, it is above everything else.

Love is like an aroma of flowers
Stimulating the senses,
Waking the ravenous hunger
Of an insatiable thirst for
Unhurried passion.
A love lies beneath
That's a light from within,
With glowing embers of passion,
Hearts racing in unison
Emotions on fire in veins.
Heat of passion unparalleled
In a crescendo of feelings
Enveloped in passionate love
Floating in ecstasy
Of a love so wonderful.
Pour the wine of love
Let it linger with a fire
A soft whisper in the soul
Conjuring passion so irresistible
Engraved in the heart forever.

This was written during my chemotherapy days in 2011, but today after two mastectomies I have a rare confidence in

life that stemmed out of the pain I went through. I no longer bother about my physical appearance, but believe in the beauty of my soul. I am happy that I found the lost 'me', and I enjoy every minute of my life. Cancer doesn't finish your life. For me, it is a second chance to love and pamper myself, to enjoy all that I wanted to and do all that I didn't have time to do. I feel I have been given a second chance to enjoy, value my life and live a life of joy with all those little things that mean a lot to me.

23

Is cancer a taboo?

Cancer is not a taboo. It is routinely portrayed as a psychological trauma throughout life. A diagnosis of cancer can be life-altering, but the assumption that it proves to be traumatic is not true: it depends on the person and the attitude taken after the diagnosis, surgery and all treatments.

It is true that cancer does cause a lot of trauma in the mind, but not to an extent of not bouncing back. I have taken this bold step to write about it because I have been seeing a lot of bleeding hearts that go out for breast cancer. I appreciate the support they are giving the survivors and those going through the cancer treatment.

The casual assumption that patients go into depression and self pity is wrong. Yes, there are people who have inhibitions talking about it. I was diagnosed with triple negative breast cancer twice, but I am today before all of you as a survivor and warrior. I would like to tell all those who are going through the trauma of cancer to delete the 'cer' from 'cancer' and take only the 'can' from it.

The 'can' means that you can fight it and emerge a winner in the battle without swords, just a smile. I, too, went through a lot of difficulties during my treatment, a lot of pain, but I drove it away even though it fell madly in love with me.

I would say that cancer made me value my life and pamper myself. I owe a lot to my hubby, brats, family and friends who stood by me like a rock. I am posting here a verse I wrote when I was in a lot of mental and physical pain, during those traumatic days. But I fought back with everything I had. I was, I am and I will always be a fortress of positivity though seasonal changes do try to weaken it now and then.

My soul died a little,
Each time I bared myself,
On the steel cold,
Examining table,
Operation table
And radiation bed.
Irony of fate,
That made me numb,
From my inside,
More than loss,
Of a part in me.
Positivity of life,
Failed to soothe,
The dignity of womanhood,
As my soul,
Ripped me apart.

Cancer struck again in May 2014, but God and my doctor were merciful by saving me from the pain of chemotherapy and radiation as it had not spread. I write this, here, not for sympathy or out of self pity --- I hate both and feel it is akin to suicide to wallow in self pity --- but with the hope that it would inspire those who are going through some pain in life or through cancer and its treatment.

I survived in spite of the stress I faced from all quarters. Just like me, have faith that you can go through it; have faith in your doctors and more so in God, for I believe that if He has given it to you, He will give you the strength to go through it. For me, my doctors have been purveyors of hope and inspiration.

24

The enticing moon over a beach

The moon rising from the horizon is a spectacular sight that entices your senses and captivates you. It is a breathtaking sight to watch the moon rise over the horizon at a panoramic beach. The moon rises every day at different times, and is seen in full splendour even in the clear blue sky while the sun sets. The moon smiles whenever it is up in the sky, like a silent reminder: "Even if you don't see me for days, I am there for you forever."

Although it is not seen for few days, as it starts waxing, it gives a sense of hope and longing to see it daily till it smiles at you in full magnificence on the full moon night.

The moon figures in all forms of art, and in literature it depicts love and emotions in varied forms. It plays a vital role in all literature. For some, moon is a sign of distress but I look out for the moon as a sign of hope. The moon can represent your emotional side and your relationship with others. They say moon is an illusion of hidden facts, but so is man, a mystery altogether.

The moon may have many unseen features. The moon's ethereal qualities create dreamy modes and pursuit of love. The moon creates a flutter and a chain of feelings. Like the intuitive nature of the moon, you understand and nurture your emotions and feelings. The different moods of man are

compared to the changing phases of the moon. The sight of full moon makes you lively with a positive feeling.

The moon has always fascinated me. I love to watch the moon wax and wane. It gives me hope. Watching the moonbeams shimmer in the water as the waves splash is a spectacular sight. The silvery net of the moon's beams spread over the crinkling sea is a wonderful gift of nature.

The moonbeams kiss the sea,
As the waves clasp one another-
And fling silvered nets,
Over the crinkling sea.
The swells of the tide,
Like emotions on the high,
In shimmering silvery silhouettes-
With splashing waves on a thrill.
Twinkling joy of reflective sparkles,
In the splendour of moon-
Completes an incompleteness,
Of a love so true.

25

Living and bonding like an eagle

Gazing at eagles, and reflecting on their lives, I had fascinating thoughts about them. Eagles are magnificent birds: beautiful and powerful. They fly very high and have a rare insight into the untold sights of life. They have the longest life span among birds; to live up to that age, they have to go through a lot of pain and process of change, and make hard decisions to survive. The life of an eagle is very inspiring as it renews the strength to survive.

I have been thinking of an eagle's way of life since I had to take hard and important decisions that brought me the wrath of a close one. It was a painful decision that I took to go through during that phase of my life; though it still pains me, I thought that if pain brings about the fulfilment of a beautiful dream, it was a risk worth taking. It tore me apart from within, knowing that my stand was a genuine one.

An eagle stirs up its nest, protects its young ones by spreading its wings and takes them up by carrying them on the very same wings. An eagle's life is a perfect example of bonding and leading; the aspect of teaching its young ones and flying away to grow up in life is something to learn from. The life of an eagle is a perfect lesson to be determined, strong willed, and perseverant to live life fully. The eagle goes through a lot of physical pain and changes in order to

survive. It renews its beak, feathers and talons going through a lot of pain.

When I was watching these eagles gliding through the sky and playfully flying around, I realised that to survive and lead a positive life, I have to go through a lot of physical pains and immense mental turmoil that was inflicted due to my difficult decisions.

I knew I would always have to rise like an eagle and keep renewing my strength and courage to face life's difficult situations. To move with a will that keeps me going and not be weary. They taught me to be a diligent seeker of positivity without any fear whatsoever.

I thought it was best to give the push needed to pursue a dream, and once it is fulfilled just watch them soar. Under that power of its spell, step aside and stay quiet; believing in their souls like an eagle does, and watch them succeed with great joy. Be there to lead them to aim high, be a guiding light but never get caged in the repercussions. Have will power, beauty and independence to gain strength on your own, follow your instincts to have a strong vision no matter what the obstacles are: remain focused and grounded.

Live like an eagle: loving the storms and rise against all odds and achieve the rightful goals. It is always better to take your time like an eagle and trust in your actions. The eagle shows you how to look after the family.

The eagle's preparation of its nest shows the path to accept changes; being pricked by a thorn is a reminder that sometimes being too comfortable with something might result in stagnation.

I understood that the thorns of life are there to teach that I need to keep growing, get out and love on no matter what. It comes as a thought process that everyone has a mind of their own and it pushes me to keep growing stronger. When I am

growing older, changes are painful and with a body growing weaker, I need a stronger will to survive the challenges that come. I prefer to be defying my fate rather than to get caged in my turmoil. What is not in my hands cannot be helped, but whatever is, I leave it to time and wait patiently.

Gazing at the sky,
Eagles gliding in joy,
Chill breeze blowing on face,
Fills a yearning in my soul,
To soar high and fly.
Breaking all shackles,
That bogs me down,
To a point of,
Tearing me apart,
With scars in my heart.
Mind rebels the reasoning,
Of a rebelling will,
Perseveres patiently,
With a selfless love,
That what is meant to be will be.

26

The beauty of being bald

I never felt baldness to be a disfigurement. Being bald does not make a person beautiful or ugly, but one can make baldness beautiful. Physical beauty is an aspect of self-esteem, a cornerstone of feeling confident but also one of the most vulnerable. I became bald by shaving my head after my second chemo, but felt beautiful and confident, too.

After my chemotherapy began, the pained looks of those around me whenever locks of my long hair came in my hand, made me shave my head. It was becoming a source of anxiety for me. Very few are lucky to feel the beauty of being bald as well as having long hair. The reason is, I didn't see baldness as a disfigurement. I realised that physical beauty can get stripped off but not the inner power and beauty.

I loved myself in my baldness, feeling special and more attractive. I never thought of wearing a wig, because I was happy the way I was, though many advised me to buy one. Embrace the baldness as being bald can be beautiful for many reasons. When one is bald, the beauty of the eyes becomes prominent; it makes you unique and remarkably different.

Surviving cancer gives you a confidence even though you are more vulnerable. You know your hair will eventually grow back. You face the cancer head on, battle with it, and conquer

it; and it is empowering, making you confident in all aspects of life.

My hair grew back after months of finishing all treatment, and got a crowning glory of curly hair: really black and beautiful. Even though I lost my eyebrows and eyelashes in the aftermath of the chemo, my eyes were lively. According to my loved ones, nothing changed the mischief in my eyes. Hair grows back, but if you give up and lose confidence, then it is difficult to bounce back in life.

The chemo of cancer,
Predicts shedding tresses,
Each time I combed,
Locks covered my hand.

Painful gazes followed me,
Better a bald head,
With a baldness full of grandeur
Than the pain I see around.

My head I shaved,
And made it bald,
Though I didn't care,
I felt more beautiful.

27

Aspects of life from a Gulmohar tree

The Gulmohar or the 'flame tree' is a common sight. In summer, the landscape is decorated with these blossoming bright flowers, adding colour and beauty to the surroundings. They look magnificent with their umbrella-like canopy.

The Gulmohar is a tree that has inspired me a lot lately for its survival instincts. The blossoms are gorgeous and make the tree look exuberant. It can tolerate the season's heat and humidity. Its bright red flowers have a faint fragrance and its leaves are small and delicate, and support the cluster of flowers. The flowers are unique: they have four red petals, and one upright petal streaked and spotted with either white or yellow. It is known to be an ornamental tree that provides shade and beauty.

I have been watching this tree in awe this year. It was fully covered with clusters of flowers. The stamen of the flower is beautiful and has a lot of memories connected with it. They make a beautiful carpet in its bower and are regarded also as one of the most beautiful trees.

Though it is an evergreen deciduous tree and remains green whenever it gets enough water, in times of water scarcity

it sheds the leaves. I saw this tree rather I observed that it had become bare to survive. It shed its leaves wherever it does not have access to water. Some other such Gulmohar trees had mixed foliage of yellow and green. A tree survives even in the toughest of situations. It has always been a metaphor of life for me. With the cancer, I realised, I had to get a part removed for my survival, much like the Gulmohar. It really doesn't make a difference because it is a question of survival against all odds.

The 'flamboyant' display of its orange-red flowers like a fire is intense, and yet, it can withstand all seasonal changes. During rains, it serenades with the music of the monsoon. With rain falling in gentle rhythm, the raindrops nestle on the leaves and hang on the tip of every tiny fern-like leaf. Nature bestows such splendid picturesque surrounding with beautiful trees and its blossoms.

Nothing is more uplifting than the sight of a tree in full bloom. Even when the sky is overcast and wind blowing, the Gulmohar's petals unfold and then fall bravely on the ground. It is a harbinger of hope, a respite from the heat: the bright colours promise vibrancy, a faith to live on and thrive in all circumstances. They are not only lively, but also bring life and positivity to everything around it.

A Gulmohar tree brings back a sea-tide of memories for many: childhood, youth, lost love. It floods me with childhood memories of decorating my nails with the buds, the lock-fighting with its stamens and a deluge of similar moments. For some reason, it spreads cheer in me. The upright spotted petals remind me of love and show a connection to the innermost self, the stamens imparting a sense of belonging to the petals that hug them in a tight bud. They bring out streaks of purity and serenity in a relationship, for those who lived with so much selfless love in them.

The flame tree continually inspires poets, flaming their poems, holding and beholding many untold stories. You can discover the hidden secrets of nature only with patience and love ... to ultimately understand that every little thing in life is part of nature. Gazing at the tree in full bloom, I realise that earth, indeed, does smile through flowers expressing its flamboyance.

Gulmohar - Delonix regia

28

Solitude by the sea

I always believe in the little joys life bestows on me. In the peace and solitude of standing by the sea with waves tickling my feet, I reflect upon the little things that came to me as blessings. What came to my mind were the beautiful sunrises and sunsets, though I love the sunset skies more. I feel there is no greater joy than watching the sun rise from the horizon standing on a beach where the waves tease me playfully.

The panorama is beautiful at the beach with the birds flying in from all sides and boats returning with their haul, while the gentle sea breeze caresses my face. It is a joy to stand in the wet sand digging in my toes, enjoying the lyrical motion of the sea as the waves dance in rhythm, and I blissfully gaze at the sun that plays hide and seek with the grey clouds. The soft sound of the big and small waves that kiss the sand seem as though it is haven for me.

These are some of my best moments, to be treasured in life by just being me and in the company of nature's miracles. It is amazing to see the alluring sea and the sunrise. There is something beautiful about standing still and watching the sunrise as it breaks through the clouds.

Albert Einstein said, "The monotony and solitude of a quiet life stimulates the mind." I feel it is a fact. The monotony

and solitude that cancer presented me made me pick up my pen to write again, just to jot down my thoughts; slowly trying to get out of a cocoon of darkness and barriers.

Gazing at the sea, I realised I had become one with nature --- what I used to be as a child. The beach and sea means different to each individual. For some it is painful, melancholic memories, while for some it is a getaway from the mundane activities of life. For me, it is a healer and an inspiration, even though it is the mountains and mist I love a lot. The music made by the waves is a soothing one without words.

The sea soothes all the stress and strain of my life as I feel one with the tranquillity that encircles me. The salty breeze gently whispers, the soft sand moulding my feet in a caressing embrace, the lapping waves kiss my toes as they undulate in and out in a mesmeric rhythm.

It is a special pleasure to watch the sunrise and its bright rays peeping out of the grey clouds; the seagulls flying across the sky is a spectacular sight to behold. The foaming sea sprays on me, creating a ripple in my heart as the waves recede with a naughtiness that brings a twinkle to my thoughts.

These memories get etched in the soul forever, even when the footprints are erased by the waves. The reflection of the sun and its bright rays in the ripple left by the waves is so beautiful and breathtaking. The golden colour reflected by the sea looks like molten gold.

The sea heals the heart, mind and soul. It is alluring and charming with a potent power. The sea and the beach are like a therapist, calming the mind that sometimes is full of disturbing thoughts. The sea breeze and the sounds of the waves can be meditative and healing. The tranquillity revitalises me.

Sensuous touch of the sea,
Waves whispering to me,
Enfolds in its embrace,
Stirs my soul,
With eternal joy.

Every grain of sand,
Tells a story,
The voice of the sea,
Speaks to my soul,
Of passions in life.

Undulating waves kiss my toes,
Leaves ripples in sand,
That tingles my feet,
Erases all footprints,
And cast a spell on me.

29

Pain and anguish of a positive soul

When a person like me --- apparently known as an 'Epitome of Positivity' --- goes through a phase of gnawing pain, emptiness or helplessness, it is hard for anyone to digest, even for me. I am an optimist and I do believe in being positive, always. But am I an 'epitome of positivity' who is refreshing and inspiring, I really don't know. I do have the faith that I don't let negative thoughts to break me that easily.

But, even the most positive person has his/her times of uncertainty and weakness, going through a lot of pain --- physical and emotional. I have been a fighter always --- I still am --- but sometimes it does become very difficult to fight a battle, as well as everything else surrounding you.

Have you ever felt so much pain there were no words to describe it? There are times when the distress and hurt seem too great to bear; you grasp for words but cannot describe the pain. Sometimes you are filled with such anguish that you are paralyzed to think clearly or take any positive steps to change a situation. But you interrupt that flood by holding on to the fact that it is just a passing phase. I really believe in what John Burroughs said: "I go to nature to be soothed and healed, and to put my senses in order."

Nature has a very unique way of healing and soothing your senses. To be one with nature is a great feeling. When I

find all my physical and emotional pains too much to handle, I feel like packing my bags and going away to the hills, to be refreshed by the misty mountains. I remember my cardiologist telling me to go to a hill station for a change, to undo all that I have gone through.

I hate the feeling of being miserable, something I have never liked in myself, especially with the battle that goes on inside me raging on. And it is then a fear is born: of may be the inevitable is nearly here, which is a cause of concern even in the most positive person. It is a feeling that roots from being helpless when you have to fight to drag yourself from the physical inefficiency that curbs certain movements in you. My friend, my family doctor, confidante, counsellor told me to just let that feeling take its stride, as it is a fight between the mind and the body.

It is not an easy task to quieten your racing heart: the feeling of a big boulder pressing your chest. Then there is the discomfort you go through when you go to bed after a tiring day, with all the aches and pains making them known with much force.

Every night, I fought the squeezing of the chest, which I was told I had no option but to live with it. Sometimes it does make you helpless. I went through a phase of fear and anxiety, but I managed to squash all those feelings and got back on my feet with a smile. I thought, if I let those feelings get the better of me, I would become an emotional wreck --- and I almost became that. I could not allow the inner spark of light to die down just like that. My physical pains have never bothered me much, so decided not to brood over things that I cannot change. Let it take its own course, as I knew it was a passing phase.

I found ways to use my time and do the things that I love to do. Everyone goes through a phase; positivity could

dwindle, due to many reasons, but then it gets back in full force.

Even today, my passing phases are always very short and I usually never let anyone get even an inkling of it. I have to live with my pains is what all doctors tell me. And I have learnt to fight it out. I realise that if I can fight the entire trauma that the emperor of maladies gave me, then I can fight out anything in life. You only make yourself miserable by brooding over things, and that stress can lead to the emperor of maladies poking its head again.

Why allow it to gnaw at my tissues again by inviting stress? So I bounced back with a smile, squashing away all that came to weaken my fortress of strength, counting the little blessings that came my way, and still come my way. Why not just work for the little wish I have in me, streamlining my time and efforts to reach my goal.

So, although, I did slip and fall within myself I decided that my fortress cannot be attacked by anything, because it is not worth it to let anything come in my way to fight my battles. They are my own battles and no one would understand anything of my trauma. When I have come so far with my head held high and a smile, why not go forward the same way?

"The greatest glory in living lies not in never falling, but in rising every time we fall." ~ Nelson Mandela.

30

The adages of life that make a Cliché

"You are as young as you feel," is an often quoted saying, which makes me think of the reality of life. As you age gracefully, you think of this quote more often. Another one is "young at heart", which is just a feeling of how you are. These often make me think of its relevance to reality of life. It is true that the soul never ages; if you can still feel warmth in your soul, then you are as young as ever, though physically you age gracefully.

At the enchanting Lake Forest, it was a descent of 200 steps to see the waterfall. I was determined to reach there even though I knew of my health conditions. It was a test of my fortitude and conditions physically. I slowly climbed down to see the waterfall. Though the water was scanty, I was enjoying the beauty of the hills, the trees and the tiny wild flowers that grew around. Climbing down the steps was not a big task. But as I started climbing up, I realised that I was getting tired and breathless. But the determination in me was stronger than the tiredness. I decided to climb up slowly, taking a few minutes' rest after every few steps. My perseverance took me to the top against all odds and the feeling of triumph was something that was worth all the pains I endured.

One may ask if it was worth the risk. And I would say --- with a beaming smile --- that it was worth all that. It was, for me, a lifeline, a test for my mind, heart and body. It was important for me to do it. And, it was a booster to my courage, strength and confidence. It was also a self-introspection of my ability to confront pain, uncertainty and danger, to gain physical confidence in life. Many may laugh at it, but my life journey made me do it, to achieve that confidence against all odds. And I realised, with a little pain, that it is all in the mind, but it also depends on the wear and tear of your body.

Aging is sometimes accompanied by the negative health side-effects of a disease in a fighting body. No anti-aging clichés, adages or quotes talks of the real story of what it is to grow older. I would say it is beautiful --- aging gracefully with wisdom, maturity, new learning and experience --- irrespective of everything. It has brought me that which is unexpected and beautiful. You can combat everything, though for some it is a crisis. The challenge lies in having the courage to change what you can, accept what cannot be changed and wisdom to know the difference.

Aging gracefully is to find a balance between the acceptance of the inevitable and doing what you can to remain healthy. Relax and enjoy all that you wanted to do but could not in the rat race of life. Find joy in the little thing. It is a reflection of your journey through childhood, youth and adulthood, to be strong in illness and loneliness; to be as majestic as the sunset.

I would finally reiterate that you are not as young as you feel: but as young as the wear and tear of your body. Yes it is true that the soul never ages or dies.

31

The gratifying deep gratitude of life

"Let us be grateful to the people who make us happy; they are the charming gardeners who make our souls blossom." ~ Marcel Proust.

The two words "Thank you" does not project gratitude, unless it comes from the core of your heart; they are just a beginning or an assurance that there is more to it than just the words. It is a reminder that words are not all, and action has to follow.

Gratitude is shown in many ways --- through affection, a note or a card with true words of appreciation, kind remembrances and a bond forever. Above all, it is a gesture by being present and available to the one whom you are grateful to.

Your journey through life makes you realise that there are a few people --- ones that came into your life to make you what you are --- with a selfless and mutual presence, to instil hope and inspire. It makes you grateful for the simple things in life. Even the smallest blessing makes you feel grateful. You are truly and greatly indebted to some that you start understanding the true meaning of gratitude, and love them wholeheartedly.

Thankfulness is fulfilled only when it comes out of you in its full sense and meaning. It is a sense of gratitude to all those who have touched you with age, mellowness, warmth, cheer, strength, care, affection, support, and inspirational hope. Online, you 'like' and appreciate without a second thought, as though those are the vital keys to being social and beholden, but when it comes to expressing the same in your offline lives, most never find the right keys or the right words.

A heart full of gratitude is a content heart, a heart that longs for a simple life. Like John Henry Jowett says, "Gratitude is a vaccine, an antitoxin and an antiseptic," gratitude opens a door to simplicity, to an experience of fulfilment in the little things of life that mean a lot; not bothering that they don't have everything and yet content; and valuing all those tangible and intangible things money cannot buy.

I owe my gratitude to all those I came across in my journey of life. I am, however, forever indebted to a few very close ones who came into my life as blessings, those who have always seen the most vulnerable and the strongest me, and known me for who I am. No words of appreciation could ever be enough to talk of my gratitude to these few.

I do owe a lot to a very few special people for all they have done during my battle with life. Some for the inspiration, some for those tiny sparks and the drilling of my slowing brain, others for the picture analysis and the words of love, appreciation and encouragement. I am grateful to them for giving me a purpose and a dream to live for. I am ever grateful to cancer for making me what and who I am today.

I have a lot to be grateful to my family and all my doctors who supported me and still support me in my battle of life, as I believe that every day I wake up and breathe is a day of victory for me. I owe my life to the Almighty who gives me the strength and courage to face the unending challenges.

I am ever grateful to the nature surrounding me: every little entity of nature for awakening in me that which I thought I could never be. For the little joys of my solitude, making me the expressive self that I was once and becoming my lifeboat. The daily rendezvous with spectacular sunsets and love for nature in its full sense and meaning. For making me realise that there is a beauty in gratitude that moves your heart and soul beyond words; for restoring that rare and special connect to everything in nature that was a love from childhood.

32

The aesthetic peacock dance

The excellent and exquisite peacock dance reflects in it the respect for beauty, honesty and peace. It loves overcast skies and rains, and that makes it dance in explicit beauty. The peacock has a vital role in music, dance, art and literature. It has its own place in folklore with many tales woven around peacocks.

Considered a beautiful, majestic and graceful bird with charming colours, a peacock is a symbol of vision, hope, watchfulness, royalty and guidance; famous for its display of its fanned feathers and dazzling plumage to attract and impress its mate. The spreading of its feathers is a vital part of its complex dance of strutting, quaking and fanning its train. The beautiful, long, iridescent feathers growing from the bird's back make its ornamental train.

One of the most beautiful birds, a peacock's beauty is legendary. Our national bird is stunningly beautiful with its neck colour and the attractive markings on its tail. The peacock's tail is a tuft of brown feathers, but the train in the middle is often mistaken for its tail. It's beautiful plumage is an inspiration with vibrant and iridescent marks, and a spectrum of different colours in it. A beautiful crest looks like a crown on its head, giving it a regal appearance.

Peacocks are usually seen with a harem of peahens. It is believed that the peahen chooses a mate on the quality of the train. A peacock uses its huge fan-like train to dance and attract the peahen. It also dances when clouds gather in the sky and it is about to rain. The dance of the peacock is significantly used in poems and works of different art forms.

I happened to witness the peacock dance in all its magnificence, in a small park near the lake in the enchanting Lake Forest. Busy pecking the ground, the peahen spends little time to gaze at the peacock when it fans the plumage and struts. The peacock's courtship dance is a celebration; of how it woos and lures the peahen. It is also a breathtaking experience. Its dexterity in the way it uses its tail feathers for its dance, its graceful movement and the rhythm of its claws --- I find it difficult to describe in words. It is great to see a peacock with its colourful plumage; it is altogether a different experience to witness it dance in the picturesque beauty of nature under a sky heavy with clouds that are about to burst and pour.

The clouds that indicate the arrival of rain tempt the peacock to dance and rejoice with its plumage spread out. This is its courtship of nature. The peacock is a symbol of integrity and the beauty; it is a sign of new breath in life which rejuvenates.

There are things in life that touch you somewhere deep inside; that streams colours in your journey of life. When dark clouds gather, the peacocks open their plumage and dance. Just like that, when it rains, you want to sing and dance --- forgetting everything else --- in gay abandon.

33

Like wild flowers in wilderness

A real lover of flowers has a special place for wild flowers. They are beautiful, colourful and fragrant, too. The range of colours, tones and shapes that wild flowers can be found is just astounding.

"May your life be like a wild flower growing freely in beauty and joy of each day." I have often wondered about the essence of this saying. Lately, its value in the full sense dawned on me: wild flowers grow in any environment and unlike other flowers, they can survive through anything.

"Little by little, it becomes at lot" is my belief. A wild flower teaches you that. You can grow like a wild flower: enjoying the little joys irrespective of what your environment is and in any condition. These wild flowers fascinate and amaze me; I pick them from the streets where they grow wildly and put them in my pots, just to see the tiny flowers bloom and be delighted by them.

Wild flowers have aesthetic value; some of them even have medicinal value. You neither understand nor appreciate them though they grow right under your nose. They say that wild flowers are the jewels of the land. There are many of these wild flowers that have a lot of significance. The baby's breath talks of everlasting love and innocence. Flowers like periwinkle signify fond memories. The beautiful forget-me-nots stand

for true love and memories. A wild flower garden can depict a 'garden of true love' or a 'Garden of memories'.

A wild flower is one that grows without being intentionally planted. The meadows are full of them. I find wild flowers special because they are naturally vibrant, subtle and unusual. They are beneficial as they attract the most beautiful butterflies, bees and birds. These wild flowers naturally adapt themselves to difficult situations in order to survive.

I learnt from them to adapt to the difficult situations of life so that I can survive, just being me.

Flowers that grow in the wild are nature's gift. They are patient and delicate in their beauty; more than just pretty, they are a natural habitat for birds, butterflies and insects with an abundant supply of nectar. Some are medicinal, some edible and filter pollutants.

The wildflowers enhance your garden by adding a palette of colours, are able to survive without any help and bring a learning experience along with the changing look of the garden.

Blooms of wild flowers,
Smiling like the radiant sun,
Creeping into my heart,
To brighten life's path.

I stroll the gravel road,
Where they grow,
Planted by magic,
With a childish frolic.

The blossoms flourish,
In mud and strife,
Dancing in glee,
When the wind blows.

The enchanting mist,
Making them lost in wilderness,
Warmth in the soul,
With something so simple and beautiful.

I feel the wild flowers,
Filling a beauty in me,
To burst into life,
Though my body is scarred.

34

The Bountiful Trees

Trees are good metaphors for life and man: though unseen underground, the roots are crucial and the most vital part of the tree as they perish without the roots. As a silent teacher, a tree has so much to share. When you walk among the trees, if you observe, and open your heart and mind to understand the ways of life, it gives you lessons of staying grounded and focused.

Trees fascinate and amaze me; I find a rare and special connect with them, and find solace being in their company. When I was a child, I used to love climbing them --- exploring them --- and every single one has a story to tell. They are everywhere, and yet you tend to just look past them without a second glance. They are life-giving gifts of nature. They wrap themselves around adversities to find light and reach the skies.

The trees help you with the awareness of self, acceptance of environment, the understanding of adversities of life, while pushing you to consciously appreciate the wonders of life, build your strength and ultimately, to be yourself. When you are in doubt, or feeling lonely, or lost, a walk among the trees can help connect with yourself, and find solace.

A tree helps us evolve and exist go through adversities of life, and yet stay calm, patient and flexible. It shows us how to face difficulties with courage and strength, endure pain and

loneliness and still rise steadily and wisely. A tree is a standing example of humble beginnings, growing even when left alone with limited means. It teaches that nothing can defeat you if you don't crumble in troubled times.

It instils in us never to let extremities of life win over us, to never ever give up in life, to have a heart like trees and be grateful to those who helped you selflessly, to enjoy the moments of life, to be strong and deep-rooted and to be steady on those roots and values.

35

Archways of Life

Two photographs --- both of them beautiful and breathtaking snaps --- taken by Asha Menon and Arun M Sivakrishna made me delve into the depths of its meaning and look over its minutest details. Some photographs touch you so deeply, that you visualise it and experience it. These two pictures, they both have similar theme of an archway of trees, but one has a railway track under it, and the other a path.

Both photographs are testimonies of nature and how life coexists in a world of diversities, and adversities. Even if the diversity is that of a road or a railway track; both lead to a path of beautiful life, it takes a traveller to decide to take that first step. He could find it soothing, and solacing to travel on a path silhouetted with trees on both sides, as it shades him from the adversities.

The landscape of a natural arch of trees is a sign of exuberance in life. It pleases and tantalises you to the core; watching them through the seasons gives you lessons in how to withstand the changing seasons of life. It takes you from the comforts of your home to the openness of the unknown, but through the security of the tunnel where the brightness of life and growth awaits. They give shade, depicting that life is a mixture of joy and sorrow.

A railway track under the tree-lined arch brings hope and a promise of an awe-inspiring way ahead. The archway of the lush green trees inspires every traveller to look for a renewed hope at their destination. Sometimes it is a corridor of trees that greet the weary traveller, amidst the mundane activities, evoking a new sense of life. These mystical trees motivate with their immense enduring strength. Among all the magical qualities of a tree, the most meaningful and thought-provoking one is the 'Tree of Life' significance that allure you the most. They promise abundance and a hope that there is potential in every season of life. They provide a powerful visual reminder of the energies you are inviting to your world.

Nature's way of providing these rare connect is through these archways: formed by stupendous trees that add beauty, serenity and positive approach. Trees are amazing and fascinating, and selfless in giving. The lush green canopy of trees is a sign of life and regeneration. They are a symbol of growth, wisdom, bounty and strength. They remind you that you are loved unconditionally and you are capable of doing beyond your imagination.

(A special thanks to Asha and Arun for sending me the photographs that reminded me about the value of trees in life, which in turn brought out this note.)

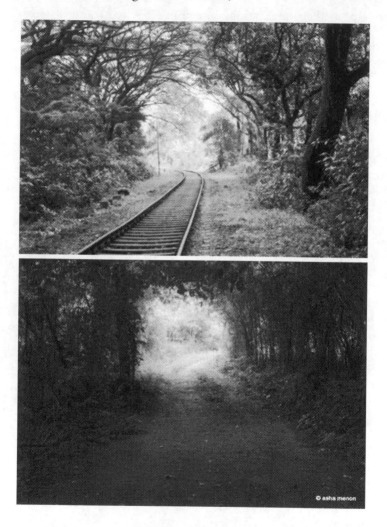

36

Kaleidoscope of Butterflies

Butterflies are symbols of life and hope. You can only experience their magical presence as they flutter from flower to flower. Their grace, elegance, tenderness and beauty is reflective of life itself, teaching the awareness that each butterfly sets aside things that it once used to know as its life and embraces an entire new way of being.

The transition of a butterfly inside the cocoon symbolises the nurturing and healing of the self by getting in touch with the essence of your soul. A butterfly is filled with the magic of 'believing': believing that you can overcome all hurdles and challenges, and still emerge beautiful on your own.

An alluring creature, the butterfly glides about in the sky and brings joy to the hearts. Looking at the fluttering butterfly, you tend to forget the struggle it has gone through to achieve its beautiful place in the breeze. But, if you believe that butterflies are a reminder of the magic of life, you can turn to it and embrace the magic.

Butterflies have a way of capturing your attention by the way they flutter around. Their flight is fascinating to watch. They are delicate flying palettes of colours that remind you how beautiful life is. They show us to be more tolerant and less judgemental of life. They make you aware that if there are no changes in life and situations, butterflies would not exist.

Everyone is a butterfly, waiting to become the most beautiful things.

Like an evolving butterfly, love each stage of your life, enjoy it without being judgemental of the transitions. Believe in your strength and faith to emerge in beauty. As Maya Angelou says, "We delight in the beauty of a butterfly, but rarely admit the changes it has gone through to achieve that beauty." It is true: you never think of the pain a butterfly has gone through in its cocoon stage. Learn from a butterfly not to count the months but the moments, and have enough time.

At the Lake Forest in Yercaud, I encountered a kaleidoscope of butterflies, fluttering from one flower to another like messengers of 'the moment', in an array of colours. My first instinct was to capture them on my mobile phone, but the butterflies surrounded me as if asking me to enjoy 'the moment' and capture them just in my heart and soul. I felt lost like Alice in Wonderland and felt my childhood revived in an ecstatic moment suspended in time.

So, I just stood there mesmerised by their beauty and thought about the pain each one of them had to go through to reach that wondrous, awe-inspiring beautiful state. I realised it is the pain that brings out the beauty in your life.

Whatever I am today is because I believe in the value of everything around me and the magic of believing. Even when you crawl in pain, it is a perception that there is a beauty in it, which makes you take flight with beautiful wings. Though the struggle is exhausting and difficult, you burst free with an awakening of renewed energy and an unknown feeling of the stretching and the spreading of the wings of joy to soar high into the skies.

The butterflies captivated my heart and soul into something I had not known till that moment. They taught me the unique feeling of transition and transformation. A

strange call for my heart, soul, mind and body, though I didn't know where life will lead me. A butterfly became a symbol of painful transformation, joy and a beauty of life after a cycle of adversities.

Those butterflies appeared to dance around me and the flowers, reminding me to take life as it comes, with a sense of lightness and joy, to go through the sequences in completing what I started; to release the energy and propel myself forward and dance even if I had to do it alone.

I dance in glee,
Wild and free,
A butterfly flutters,
Alighting on my shoulder.

I close my eyes,
In rapturous ecstasy,
Of the moment that,
Creates magic in my soul.

A brief moment of,
Its love and beauty,
A rush of wings,
And then it's gone.

Brush of a miracle,
Etched in my heart,
A butterfly moment,
That lasts forever.

37

The enchanting Lake Forest

"Nature is a source of solace, inspiration, healing, adventure and delight; also a home, teacher and companion."

Yercaud is a mist-clad lake forest and hill station that refreshes, rejuvenates, heals and delights your very being. Everything about it touches something deep inside your soul. As you go up the mountains, the breathtaking views enthral you with the hairpin bends and stunning vistas of the twists above and below. As you climb it is amazing to see the sun play hide and seek with the mist, the clouds playing a mischievous touch and go game --- everything around embraces you to etch a beautiful painting in your heart and soul.

The morning chill, the mild breeze, the mysterious mist, the canopy of the forest at the foot of gorgeous hills, the rains, even the sea of twinkling lights at night turns the place into an enchanting jewel of the south.

The chilly breeze flows in through your nose but rejuvenates your soul. The cool and crispy rain hits you and awakens you to a fantastic view of your surroundings. The flowers and the butterflies take you through an enchanting journey of life, reminding you of the beauty of life, its meaning and mysteries. You see butterflies kiss each flower, which dance in the gentle breeze in a ballet of mystical magnificence.

The Lake Forest is where you realise the meaning of the verse: 'Count your garden by the flowers, never the leaves that fall.'

Even the fallen leaves and flowers make a fragrant carpet. Each flower and butterfly is a sight to behold. The tall tree with silvery leaves, the pepper clinging trees with its green and red corns --- they all make the mystic panorama breathtaking and beautiful.

It is a magical landscape of unparalleled natural freshness. The undulating hills bathed in bluish green hue, the clouds bending down to hug those hills, lush valley and forest drenched in the sunshine with veils of mist roaming aimlessly, the fresh air --- all these are the many moods of the enchanting lake forest.

The hills caressed by a blanket of mist that steals in silently hides the landscape under its mysterious cloak and clears suddenly, contradicts itself the way it conceals and reveals. The mist swathes and discloses the beauty of the hills at regular intervals. The mountains get enveloped with clouds and you can see nothing but mist which keeps hugging you and enhances the experience, especially when you love the hills and the mist.

Yercaud is a picturesque misty soul station with the scintillating lake surrounded by flowers and garden. The lovely placid lake entices you to take a boat ride and drink in the beauty of the calmness. Birds just glide in the wind here and the valley is amazing to watch. Even in heavy rainfall, the sun shines out in its full splendour, leaving you to admire in open-mouthed adoration the rare sight of rain in the setting sun.

As the wind whistles in your ear, the cluster of rocks, the valley and the forest from different viewpoints are uniquely beautiful. The panoramic view of the plains and the bends in

the Ghats seen through the top of the trees leave you in a state of pure bliss.

At night, the whole place looks seductive with a sea of lights while the night sky glitters with the winking stars. You are mesmerised by the view as night falls and Salem lights up at the foot of the hill as if it is glittering because a sea of stars have fallen from the sky. Sometimes the mist engulfs and all of a sudden, the spooky breeze chills your spine.

The Lake Forest refreshes and rejuvenates you, all you need to do is relax and inhale the fresh mountain air and you can feel your heart and soul dancing to the music of the allure of the valley.

"The enchanting Lake Forest beckons me,
Where nature whispers sweet nothings,
Where the clouds touch your heart,
Where the sky tempts you to soar high,
Where the depths of the valley invite,
Where the lush greenery of canopy in forest lures,
Where the sea of lights glitter like gems,
Where stupendous sunsets outshine rains,
Where mist hides you in its magic cloak,
Where peacocks dance with all its significance,
Where the hills are bathed in twilight light,
Where the chill breeze whistles and caresses you,
Where the scintillating lake allures you to drink in, its beauty,
Where rustle of leaves stir up your mind,
Where majestic silver oak trees standing tall evoke,
Where birds just glide in the wind,
Where butterflies flutter in magic of 'the moment,'
Where fragrance of the beautiful flowers enthral,
Where rain drenches you to quench your soul."

38

The picturesque clouds of my life

"Clouds come floating into my life, no longer to carry rain or usher storm but to add colour to my sunset sky." ~ Rabindranath Tagore

Clouds mean different things to different persons. I grew up understanding the positive aspect of clouds, that they come floating to add colour to my life. And today, watching the sunset skies, the understanding is deepened.

It is your attitude towards life that changes every perspective of life. Take the example of the clouds: if you lift your eyes and look at them, what you think of them --- be it poetic, realistic, romantic or scientific thoughts --- makes you either forget or remember. It takes you back to your roots. Best part of life is to watch them, feel them and enjoy them.

A cloudy sky is more picturesque than a clear sky. A cloudless sky is said to be like a garden without flowers. You can see the most beautiful colours in a cloudy sky, a true cradle of nature to soothe your heart, mind and soul. Gaze upon the horizon and get enraptured by them as they part. Be speechless and travel with them to a mystical land where clouds usher in the picturesque life.

To cite Nathaniel Hawthorne: "When scattered clouds are resting on the bosom of hills, it looks as if one might climb

into heavenly region, earth being so intermixed with sky, and gradually transformed into it."

It is a memorable experience to feel the clouds on top of a hill. They just roll in making you feel that you could really walk among the clouds. Sometimes clouds provide the most magnificent, breathtaking, and panoramic view --- in a valley, on a hill, even over the sea. Clouds are a great metaphor in poetry and literature; they symbolise both negative and positive forces --- struggles, challenges, aspiration, dreams and hopes.

When the sky is overcast, the setting sun displays an array of colours while the heavy grey clouds form patterns in the sky. You can visualise them anyway you want in your mind. They just float while changing their appearance, as if they are in a theatrical realm. Laced with rainbow colours, at times, even the darkest clouds induce hope.

Clouds are constantly changing and moving; casting your eyes on the sky, you can infuse your own feelings into them. It is inspiring to watch the different patterns of clouds. Standing on top of the hills, clouds that come swirling all over bring with them a whiff of freshness and the fragrance of rain. When silhouetted in the blue sky, the stunning landscape of the clouds forming patterns in different shades reminds you that life is beautiful.

39

A flame that ignites every fibre of soul

Spark... Light... Ignite...
Sometimes a spark is all it takes for a fire to rise to its fullest height, resolving to soar above all the debris of doubts and confusion. It sounds easy, although it actually is very difficult. It is also not impossible. All it needs is the ignition to create a ring of flame.

It is with the positive fire of determination, perseverance, belief and hope that you wish for the best. An eternal flame of faith is always triumphant. Just a spark of hope and a gentle whisper of faith ignite your will to persevere and believe. The fire of belief still burning in your soul, you always hope for your efforts to be fruitful and that the flames of hope keep your heart warm.

Optimism is the positive spark that drives you believe, expect and hope that things will turn out well. It is the belief that in spite of the setbacks and delays, the outcome will be a positive. It is this spark of hope, strength and belief that can take you a long way in your journey of life.

Believe... Faith... Hope...

Faith is being sure of something that you hope for. Believing and having faith are very closely related --- even correlated --- but understanding the vital difference clears up a lot of doubts and confusions. However, unless you have hope, believing and having faith are both futile. You need to have faith --- even as small as a mustard seed will do --- that is what is believed and hoped for will be, and that makes all the difference.

It is said that belief is an opinion or judgement that completely persuades, and faith is to believe, to take efforts and have confidence in them. The difference is subtle, but it is there. When you believe in the confidence of your efforts, you use your faith to make things happen.

Believe in the inner spark, hope to light up that spark and have faith to ignite those in your efforts. It is a spark of hope to believe in something and the faith to fulfil your life's dreams.

Aspire... Inspire... Achieve...

Aspire to go forward in life, inspire yourself with a spark of hope and believe in your faith to achieve what you aspire for. To do all this, you have to transform that spark into a flame and go in the right direction --- to take the effort to get the best outcome for your hard work.

To aspire is to rise above all obstacles with abundant hope of fulfilling the work you started. The challenges and hurdles on life's path are many; aspire to inspire and achieve new heights, gain strength from the hurdles and be courageous to blaze; aspire to take the directions with hope and courage to continue your journey.

If the spark within you dwindles, fan it into flames to light up you life and inspire yourself to go forward in your journey. Work hard to let miracles happen to you, and go ahead with

the belief that what you have hoped and dreamt for will pave way for success. Inspire yourself, reinforce your faith and be a reminder of positivity of life. It is only the positive spark that lights the flame and ignites hope in every fibre of your soul, mind, heart and body.

The ones who bring meaning to our lives, who happen to inspire, who sparks a fire is us are pillars of hope and sometimes life-changers.

40

Sunsets as landscape and whisper of my heart and soul

Sunsets are always so resplendent that you fall in love with them over and over again. They, at times, turn out to be whispers of a lonely heart. Sunsets are always spectacular: backdrops with an array of colours, afire in warm glow. They are magnificently moving for an aching heart; they encompass your body to feel the rhythm of everything around you. At times, they are so beautiful and mesmerising, they take your breath away and make your heart race and leave you in awe of the display of colours.

This one sunset, where the sun was caught up in a huge dark grey heart: emanating yellow rays in a silhouette of white fluffy clouds that had pinkish hue captivated me. It looked like the sun, a fiery red ball, was perched on the tree top. Birds were flying across a sky that was awash with shades of pink, white, yellow and tinges of purple.

For a few seconds, the sun was swallowed by clouds. It was an image that was shining with beauty of the hues with comforting stillness and the calmness truly amazed me. The sky lit up into a pinkish-purple palette: bright grey rays shading the sky into a pink and peach. A twilight curtain was spreading a feeling of warmth through my veins.

The canvas of the sky is painted differently with vibrant colours, each evening, making it magical. It spreads a light within me through its breathtaking beauty. The most gorgeous sunset was leaving me with a feeling of love and tenderness that I had never known before, healing all my aches and pains. I realised there is a sunset within each one of us.

I love sunsets; because no matter whatever happens it inspires me with a hope and glory of life. It never fails to heal me. Sunsets for me are a metaphor of joy, gazing at the Creator's masterpieces every evening. When I watch the sun set every evening --- from its descent till it disappears below the horizon --- I experience a love that makes me enjoy the solitude as I watch the sky, the sun and the birds while the gentle breeze caresses me.

The beauty of each sunset brightens up my life and fills me with wonder.

Life waits for me,
Just beyond the horizon,
Where I find a treasure,
Of eternal love.

In the expanse of the sky,
A paradise of colours,
Where you'll find me,
If you care to see.

If you listen to the magic in sunsets,
Its silent sighs,
With beautiful rays,
Spreading a light of hope.

I long for the moments,
When the twilight curtain,
Drops down with a palette of
Artistic tapestry across the sky.

41

The mountainous trekking of life

Life is like a mountain, with its highs and lows; many a time you have to change your course and speed to reach the peak. What is important to remember is that you are heading forward in life's journey.

On a mountainous path you could be on a well travelled or less travelled road. Sometimes you reach an unknown territory that may seem difficult. Just like these mountains, as you climb up in life there may be obstacles that seem insurmountable and you may stumble and bruise yourself. But just remember, though the path is difficult, when you reach the top after having gone through everything, the view is breathtaking and beautiful. After all the hairpin bends in your path, there is the majestic summit which is worth all the pain.

If you really take time to know deep within that you need to climb a mountain, it then holds meaning for you. When you climb and get good tidings, peace will flow as sunshine flows into trees and the wind will storm energy into you. It is a great challenge, but when you reach the top, you will realise it was worth all the aches and bruises.

Climb the mountain of life slowly; enjoy the view, face all obstacles, keep the good moments and forget the hard ascent through boulders and rock. You go through exciting

adventures; all that matters is you take the challenges with courage and determination.

Life's destination is to learn from the journey and ascend to the peak. Life's path is also like mountains: it needs stopovers to rest and to look around, to learn to enjoy the moments. Mountains, like all wildernesses, challenge you with their winding paths and harsh conditions. And the depletion of oxygen and bruising yourself on rocks, tired muscles are all metaphors of how you want to just give up. Your part to play in the journey is to keep putting effort which, in turn, gives you a big sense of accomplishment.

It is proof that you can also go through anything in life and that is worth your efforts, despite the fear and doubts. No one can take away that.

There is something about natural landscapes that instil inspiration. You think of a mountain and it connects to so many aspects of life. The sight of a misty mountain has a magical effect on you. A mountain is a strange metaphor for the insignificance of man, but also an awesome reminder of nature. It depicts stability, obstacles, strength and courage. Climbing a mountain is a metaphor for overcoming obstacles and challenges life throws at you. It indicates adventure and can also be seen as a pinnacle of life.

Climbing some peaks of life needs nerves of steel. Most people love the valley below because they feel it is secure, familiar and comfortable. Very few opt for the mountains due to the challenges it holds and the effort that it needs to climb involves lot of stress, hardships and discomfort. It needs a great deal of courage. Those who reach the top know that it is worth the effort and that is the secret of life.

If you are faced with a mountain, you have several options: you can climb it and cross to the other side; you can go around it, you can dig under it or fly over it, which is easiest.

You can also ignore it and pretend it is not there. You can turn around and go back. Or you can stay on it and make it your home, stand there in admiration, breathing in the misty fresh air, and enjoy every bit of it. It is up to you. Keep close to nature's heart and wash your soul clean. For me, the mountains of nature and life are always with me and I love them. They inspire me and fill me with a tranquil serenity.

42

The Awe-Inspiring beauty of the insignificant

"A tiny flower could bring joy in many ways."

Often it is the unnoticed and the unseen that adds beauty to life. Those small things, which may seem unimportant, meaningless or inconsequential, become the most beautiful and awe-inspiring things in life. Sometimes, life has a way of making us look at our journey and reflect on the most insignificant parts, which startles you as you realise that the insignificants were the very core of your life.

A journey of life that was filled with pains, obstacles and challenges that you overcame with a smile and yet end up feeling that it had no significance whatsoever, even when it was a struggle of the very life, it makes you look at the tiny, small events that you missed or left behind as insignificant.

All these contemplation came through when I was admiring the baby's breath and the bougainvillea flowers. Baby's breath is the cluster of tiny white flowers that stand for their purity, innocence and everlasting love. Baby's breath flowers are tender, delicate and quick to bloom.

These tiny flowers are seen in most bouquets; that's how I started loving them. In those days, I never knew they were

called the baby's breath. The tiny white flowers gained my admiration and adoration, when my friend, Suja Rachel Joseph, started sending me photographs of these delicate blossoms.

Similarly, the actual flower of the bougainvillea is also a cluster. It is small and usually white, but each cluster of three flowers is surrounded by three or six bracts with bright colours. They are known as paper flowers because of the papery quality of the bracts. When I closely looked at the small flowers, I found them to be enticing. A single bougainvillea flower is small with tinges of green and pink, and a tiny yellow stamen. It is seen in many houses and on the streets, but I never stopped to look at this one like I used to stop for other flowers. Somehow I did one day and it made me think: there is nothing insignificant in life.

A notation on a symbolic photograph by Arun M Sivakrishna said, "Like tiny wild flowers, hope brightens up even the darkest of corners." It shows the importance of looking at all the small things with a different perspective. To see a tiny flower bloom in intricately woven beauty is definitely one that inspires me to hope and be happy.

I think of the weeds --- the least looked at unless they are overwhelming a pristine garden --- which always gives the highest hope in time of need. Its insignificance is its beauty; it is a rebel that grows anywhere though least sought after or looked after. All these 'insignificants' give out a positive message to those who look for it.

On a collective note, you are just a flash in the pan. Sometimes you insignificantly do a lot --- not for the sake of being recognised as someone who really worked for something, but for the welfare on the whole. You make a lot of sacrifices; go to great pains to create something good. Every single thing is important; it is never insignificant, though it may seem to be at a point of time. A rebel with a lot of how, why, when, what,

who, where, is always an insignificant entity for many reasons, but the significance shines out when you least expect it.

"Tiny is the flower, yet it scents the grasses around it." It is a 'ripple effect', that says small things may have a larger effect. It doesn't matter how small you are in certain aspects of life. It is easy to acknowledge words and things you can see. It may not be significant to many, but they are reflected in many ways. You start realizing the value of the insignificant things when you value the core of life.

Positive thoughts may irritate many, but its value is known only when you realise that being positive alone can make you fight life itself. Loving the insignificance of life may be like a telepathic message that many fail to understand.

Spoken words just brush past into nothingness as it is not valued. But the unspoken, the unseen, the unnoticed become very significant when you are fighting a lone battle of life itself, bearing the brunt of everything and many a time the value of it is realised and longed for when it is lost forever with life itself. To thrive when conditions are good is easy, but to thrive in unfavourable conditions of life needs grit and perseverance. It is then the value of a positive influence is felt the most. It makes you love all the small things that were immaterial in life. You value and hold close all those little blessings and moments that came into your life to give new meanings and help you fight during challenging times. All the little things become the most important ones that give immense joy.

I love tiny flowers, weeds and all those little things that others feel as insignificant. In the light of what's happening, it is more imperative for me to always have a positive and upbeat attitude. It is not what happens to me that count, but how I react to all that is happening. A positive attitude can cause a chain of reactions, being a catalyst and a spark.

"Glow in positive influence,
Though tiny and insignificant,
Its effect you may not see,
It may spread in ripples,
And make a difference,
In the path of life."

43

A longing heart in the tree of life

Love, affection and care, if you don't get them back, they give a throbbing feeling which could even be a torture on your soul. If you take it that way, it is a feeling of complete despair as you hopelessly, desperately love all the while knowing it will never be returned; it is one which makes the heart ache but also gives you joy of going through that agony. The pangs of unreturned affection never really dies... it goes into hiding in a remote corner of your heart.

Longing for lost affection, love and care is as futile as searching for the sun after it sets. Unrequited love, which I have known since I learnt what love really meant, is loving someone so much even when knowing it will never be returned. It is an unselfish unconditional feeling that makes you love someone with no motive behind it. It craves only for the well being of that person without invading their privacy and happiness. It is never a fantasy of life.

Love is the greatest feeling in the world. It makes your heart race, makes you feel like being on top of a mountain, walking on misty air with a whiff of the cold breeze caressing you. Unfortunately, just when you think your feet may never touch the ground, you can find yourself being crushed by a sweet agony and an intense longing.

It is a chemistry that doesn't work, not because you are not worthy but because the other person couldn't or wouldn't reciprocate; it just leaves a sweet lull if you have loved right. Love, affection, care --- these are things money cannot buy.

Unrequited love is neither physical nor psychological: it is emotional as there are a lot of sentiments attached. Never is it a confusion of need nor an obsession. Love is never possessively obsessive. Love is never a fantasy to find someone or something that is missing in your life. An unrequited love is that hidden burning flame which wants only the best for a person, and no other motive. The first love, and pain experienced because of it, always hides in the corner of your heart; a sweet agony that you always remember.

Any bond of life can get unrequited, when the yardsticks are different for all. That, too, gives an aching and longing, but always a sweet one. While nothing beats the burst of happiness that mutual love can give you, nothing can feel as painful as experiencing unrequited love. But obsessive limerence is dangerous. One of the hardest things in life is having words in your heart that you can't utter. The heart is full; leave it to overflow on its own silently. It heals you of all pains endured. As Washington Irving said, "Love is never lost. If not reciprocated, it will flow back and soften and purify the heart."

44

A sunset to muse over my lifetime

Some memories always warm you up from inside. It brings forth a deluge of sentiments that overwhelms you, but also makes you smile. It could be due to the unexpected turn of events that made it a garland of beautiful memories to drift through all the pains of life. It will always be remembered because it holds so much emotional value you never want to let it go.

One such was a trip to Mysore --- it was neither official nor a vacation. It was a detour to meet a little one. It was meant to be an experiment of a mother and a teacher to find answers for many rebelling questions. It was like meeting a long lost family. A rapport built through letters and phone calls. It was a reunion of an unforeseen bond, between a son and mom.

Travelling to Mangalore was another unexpected and an unforeseen journey. Sometimes, such unforeseen events captivate the heart and mind to make beautiful memories. When a journey is not pre-planned, or even predestined, it becomes a wonderful experience and the resulting joy is boundless.

Driving is one of the best ways to enjoy a peaceful journey through a picturesque road, leaving one wonderstruck at its beauty. What made my road trip more special were the little titbits exchanged and the mischief that always lingered in between the light chatter.

Though I knew that that stretch of Western Ghats was full of breathtaking views which mesmerise those who travel by, I was awestruck by the spell-binding scenic drive. I have always been a nature lover and the mountains always enthral me. There is a unique enchantment that suddenly takes you unawares when you behold the wondrous beauty of an unknown territory, which you have only seen in some rare photographs but wish to see for yourself.

While driving through the scenic route, I sat rooted to my seat for the first time in my life, with the excitement of a child. It was like seeing something that I had only visualised after looking at a captivating picture.

The foliage in different shades of green, the eye-catching oranges, yellows and browns of leaves really took my breath away. But the hairpin bends and screeching tyres brought me back to reality. As we travelled along the bends, down below I could see the majestic carpet of the trees that were proudly displaying their greenery. The sight of the trees along the roadside with different coloured foliage was like revisiting something that you have seen and admired. I sat wondering what it was that made it so breathtaking. Was it seeing in person the beauty that was imprinted in your heart through a photograph or the joy of being able to see something that your mind only visualised?

As I sat watching the beauty of the Ghats, I could see the sun changing its colour, getting ready to go disappear behind the mountains. The sunset is always magical and mountains added to the magic. For me, there is something about the sunset that connects with a deeper part of myself; with the amazement of a realisation that one day of my life, though fleeting, is a sunset to remember for the rest of my lifetime.

The bright hues with the comforting stillness of the surrounding sky made it an image that still shines within

me. There's something very calming about the setting sun: as the day fades into night there is the promise of a new sunrise the next day. As I soaked this in, I was reminded what a truly spectacular sunset it was. It was a blessing to have seen the sun disappear behind the mountains. I watched with an unwavering gaze as the fiery red orb of light slowly sank behind the mountains, but threads of light lingered in the sky, the glowing embers of a dying fire of red looked down, illuminating a curtain in the sky.

The best part of any journey is to enjoy that beauty around you with an added bit of laughter. It doubles when your fellow travellers, too, enjoy the scenery. It was a drive to remember as the atmosphere turned affectionate with a unique sense of belonging, like with a family.

There is something very special about the bond that was nurturing. It was like a family get-together. It is said that a mother makes an indelible imprint on her children's lives, even a grown one. It was a moment when motherly affection in the unforeseen bond before the meeting silently transformed into a unique one of understanding.

Of all the riches and assets we acquire in life, perhaps the most valuable one are our memories. They cannot be stolen or taken away from us. Memories can be replayed, relived, and rejoiced at all times, anywhere; it gives us immense joy as they rustle through our mind. The older one gets, the larger our memory bank becomes and like anything else in life, they energise us in the sunset of life. The memories that stay with us the longest are those that resonate with experiences of love, giving, compassion and laughter.

Every waking moment of daily life, and some of the non-waking moments, we keep making memories. Majority of them vanish before the day is gone, but some come back when reminders come along. We deal with the lost ones by

writing diaries or taking photos and it all helps in the quiet moments of life as we age. To reflect upon these cherished memories with loved ones keeps us going in the painful moments of life.

45

In the fleeting dewdrops of life

Life is transitory like a dewdrop on a blade of grass. In the gentle breeze, the dewdrop plays on the grass blade, sliding down till it comes to the tip and hangs there in all its brilliance, like a diamond. It reflects the world around it in all its splendour, symbolising the life you live. The dewdrops that fall on the tall grass blades balance delicately, resolving to enjoy the fleeting moment they have been given. They slide down in oblivion either to splash down into a no man's land or to become one with the whole.

We cannot visualise anything more breathtakingly beautiful than a spider's web covered with dewdrops that radiate beauty in the morning sunlight. Every dewdrop in it reflects the other dewdrops and the world around it, showing that life is always intimately connected to everything around you. It is a sight that makes you stand in awe, gazing at the spider's web with the dew drops shining like diamonds and the spider in the middle of it. It is intriguing as it is like a man caught in a web of his own circumstances. The spider patiently and painstakingly weaves a web and the finely spun web shows the invisible tiny threads that connects us to the people in our life. The dewdrops glistening on it are like the reflection of those connections in life.

The dew of life forms beautiful drops and the sun's rays make them look like diamonds with tints of rainbow in them. When you see, hear and feel the wondrous ways of nature, it starts giving you a better insight into life. Each tiny dewdrop comes from nature and will return to it. Every tiny droplet has its own unique beautiful shape and each one carries its own world inside it, its own reflection of everything around it. It is really precious to be shinning in the sun, showing its own unique self, the endless way of engaging the life span it has been given.

Observing these tiny dewdrops in the morning really awakens and improves a day; reminding you of the true and precious nature of your life, how a tiny entity can be a blessing that brings light and motivation to your thoughts. They make you realise that it is better to allow light to shine through you, and not grumble or groan through life making yourself miserable.

The dewdrop that is caught in the light, making it glow with rainbow colours is an unequalled gem of nature. So are you: precious, unique and different in your own way. The dewdrops seen in the morning is a spark of inspiration to the soul.

The dewdrop, though a tiny entity, is a reminder that radiates hope. It is nurturing the power of hope, faith, trust, and compassion. It is pure nourishment to the soul. A tiny entity of the universe, the dewdrop is a metaphor for the fusion of an individual and inspires the 'now' in you. The tiny ball of water has inside it all the colours of the universe. The dewdrop greets you afresh in the morning, making you realise that every moment of life is precious and to be cherished before it disappears forever.

You too can be content with life like a dewdrop and also reflect the best and most special, in your own way. Just like a

dewdrop, shine while it lasts and then give in with radiance to become one with the whole. I love to play with dew drops that come in the wee hours just at the arrival of dawn. To see the drops hanging so delicately on a blade of grass or a petal, picking up colours around it is just enthralling. All the colours and the world around them held inside a tiny ball of water, suspended in the air is a feast to the eyes and joy to the beholder.

> "Every dewdrop is a tiny entity of this endless universe.
> Each reflecting its own surroundings,
> Radiating light from the other like a diamond,
> A tiny entity of life,
> Radiantly carrying a world of its own."

46

The journey of a blooming bud

"And the day came when the risk to remain tight in a bud was more painful than the risk it took to blossom."
~ Anais Nin.

It is a great dichotomy of life: The image of a bud painfully clenched and the inevitable pain in the process are the types of situations that happen in life sometimes. It is a reflection of the helplessness of certain situations. It is finding a new meaning to the quote, a determined magic of getting out of a pain which has to be defeated, because remaining in that pain would be just stopping your fight for life.

It is hard to be in that emotional 'rock bottom' state, which tends to torture your very core. You struggle to find a release that you need for the significant change of your emotions. It is an outcry of reaching the end of your rope and then realising there is a greater fight for your well being.

The opening of you from that bud of mental turmoil is your blossoming. The petals release from the cluster with abandon, spreading into a beautiful bloom. The energy released in the process is great, so is the pain that engulfs you. The pained soul would have loved to remain in that state, but it is difficult for a fighter to accept it.

That is the time of the outburst of the soul; the pain is released giving an inspiration to keep fighting with a new sense of commitment. No one may see it, but it is you remaining 'you' with the fulfilment of your promise to grow, bud and bloom, whatever happens. It is your will to fight and persevere that is at stake, so you have to come out of the bud of pain that engulfed you and bloom with a positive glow.

The bud within me has to bloom, however hard the struggle is, unless I want it to wither and die. And I am not made that way, nor do I want to live with that pain. It is not like me to do that. Those moments of pain are too hard to take and it feels like my chest would rip open, but it is always better to wrap your arms around yourself and say: "I have to do it. I have to come out of it. I can't become a victim to this."

You feel you are at the edge of a cliff and the knots in your stomach prevent you from leaping and then you realise you are strong enough to withstand it. You find that the ache swells up and it suffocates you, making you think how a fighter like you could come to such a rock bottom state.

Even 'positive' persons are human. Even if they are born fighters, there are moments that make them impossible to live through, because they feel it is not in their hands to possibly mend a situation, and being brave alone doesn't help.

When you fight and come out of such a situation, it is like being given the choice to remain within your bud of pain or go through that pain and bloom with renewed hope and spread the petals and let the fragrance spread.

47

The twilight glow of my life

Twilight is the light between day and night; the illuminations of the sky by the scattering light as the sun sets. Twilight is that time of the day between light and darkness, when the sky is diffused with several colours. The sun dips below the horizon and its scattered rays creates a magical colourful curtain in the sky. The soft glowing light and hues of the sky when the sun disappears is awe-inspiring.

The sunset is different each day. Each day it gives a different experience. But the magic it creates daily is something that is constant. Sometime the twilight is grey with hues of pink, but its grandeur with different shaded clouds spread across the sky leaves you spellbound. With tints that harmonise the sky, twilight drops the curtains of colours on the day. It is a transition between day and night, revealing the magic in it and the daily moments of life. The twilight colours attract the eye.

"Twilight is a time of pause when nature changes." Twilight is also the fading away of light or vigour as you grow older; but it is also a mystery of life. In the twilight of life, perhaps energy starts dwindling, but some people never wane in life, they just become less energetic. It is the attitude towards life that consequently decides what the twilight years hold for you. Let it not eclipse your life completely.

The word "Twilight" has always attracted me; as does the twilight that comes twice in a day. It is, however, the twilight after sunset that captivates my heart and soul. As Ralph Fletcher writes in the book, Twilight comes twice: "It stays only for a short time, while day and night, and stands whispering their secrets, before they go their separate ways." Twilight is the glow of life which promises you before darkness set in that it doesn't last long and the sun will rise again with twilight of hope.

The challenges and struggles in life are also not permanent. So when darkness falls on life, think of all the light that radiates in your life and look forward to the new day. There is nothing in life that spreads permanent darkness, but you need the will to tide over it. It is all in the mind and your attitude towards life's challenges. Fighting the blues and challenges in the twilight of life makes me feel alive. Life is unknown, so is the twilight of your life. But I find my glow in the twilight. To make it amazing is in your hands by reflecting the positive rays of life.

Everyone must have marvelled at the magnificence of the sunrise and sunset at some point. The twilight sky inspires awe even when it is devoid of clouds. However, the most memorable ones are those with the clouds that catch the colours of the setting sun and reflect on the ground. It is the clouds that make the twilight more eye-catching producing vivid colours, making it spectacular with lovely hues. It is when the sun disappears behind dark grey clouds the best colours are reflected by the white fluffy one above. I have wondered many a time when I see such a twilight, why the grey clouds are considered drab and dull, when the light of the fading sun reflected such beautiful colours from them.

48

Tiny parachutes of life

Life reverberates like a dandelion blowing in the wind, which could be why man always searches... and wonders how the dandelions can bloom and then fade away into fluffy white pieces at the slightest breeze.

A dandelion floats in the wind seemingly free and unrestrained, but is actually not acting of its own will. The dandelion gives hope that if it falls, new life is generated, continuing in a different way, cultivating a sense of wonder to keep it fresh in all areas. Life is like the seeds that get blown out in the wind but planting new choices and new areas of growth.

A dandelion can grow in any place and survive even in the toughest of environment. It also has a deep root system that allows it to withstand anything. Its transformation is a beautiful one against all odds. Dandelions are blown in the wind, like the choices of life, the making of 'you' and the attitude towards life and challenges. Even though they are at the mercy of the wind, they still give hope of life and strength, and the courage to navigate through all the strong winds and storms that threaten their very existence.

Dandelions are symbols of positivism, progress and survival. The fluffy white dandelion seeds, each a tiny parachute flying in the wind is a positive influence, a source

of inspiration, determination and a wilful directive to survive against all odds.

They are also a reminder to reflect on what kind of 'thought-seeds' you are planting. It is an awakening to bring out an unassuming you, with the puffball explosion of inspiration, clarity and insight into life.

It is always the simple things that matter the most in life, asking you to see your inner strength every time you face obstacles and challenges that throw you off balance. Life is a struggle and your strength will take you forward.

Once it dries, a dandelion flower's tiny individual parachutes fly off to settle and grow wherever the wind takes them. They remind you of those souls who love to see the dandelions and watch its tiny parachutes waft in air with wonder and sheer delight.

It is loved for its delicate elegant and simple beauty which makes it stand out in a crowd despite its smallness. While they live, they stand strong, reminding you to live life to the fullest and never give up, no matter what comes in your life.

Each man is one on his own just as the dandelions are. It is accepted as a flower-weed that leaves its indelible imprints on the heart and mind, just like man who thrives on the reality of life. Dandelions are symbols of courage and cheerfulness. They thrive and grow withstanding all uncertainties of life. Even in adversities, they manage to thrive with a cheer, comfort and hope. There is a lot man can learn from dandelions. Life and dandelions are similar in a lot of ways. Depends on what you intend to derive from it. Like the dandelions you, too, can be tough to withstand any environment, with its adaptability to any conditions, be cheerful and strong. It can speak volumes, if you take the time to observe them. A tiny parachute of life, that gives strength, courage, positivity and hope.

"Tiny parachutes of life,
Puffball explosion of inspiration,
Flying at their will in air,
Of dandelions that withstand,
With roots stretched deep down,
To overcome all,
To stand tall and beautiful,
A flower but as a simple weed."

49

The resonance in reverberations

In every sound there is hidden music, especially the blissful sounds of nature, those that go deep into the heart and soul, giving an eternal joy and washing away all anxiety. There is music in nature, in every sound you hear, it is the distinction of sounds that makes it a lovely melody and harmony. All my life I have been a lover of sounds, be it those heard from nature or the ones from a machine.

"Magnetic Resonance Imaging (MRI)", is a medical imaging used in radiology to investigate the anatomy and the functioning of the body in both health and disease. It was the second time I was going under this scanner. Every time I underwent a scan, I found it to be a new experience. It was like going into a sophisticated cave, listening to a lot of sounds and echoes and then emerging out into the open with your ear still buzzing with sounds. I had wished they allowed an ear plug with music in it. As that could not be done, I was lying down and trying to find the musical notes in those sounds.

As the scanning process started, I could hear clicking, hammering, single sounds, which picked momentum and turned into louder and continuous clicks, thumps and scraping noises, in which I tried to find some kind of melody. The most important thing during the process was that I lie in the same position without any movement --- with my hands

up --- and surrender to the machine's sounds. The hand's awkward position was necessary to inject the contrast dye into the IV Line, fixed prior to the scan.

While the MRI itself caused no pain, having to lie still for the length of the procedure caused me some discomfort. As the scan progressed, the sounds became louder making me wonder about those sounds I was able to hear. Though there was a certain rhythm in it, I was trying to listen to them as they were the best music I had heard. At one point, I felt my heartbeat was a better sound to listen, but then I tried to synchronise it to the sounds around me.

I was trying to feel the resonance of the sounds reverberating around me from the metallic little cave I was reeled into, to find whether the cancer had reinstated its attack on my tissues again. Instead of the sounds of music, I was trying to find music in the sounds coming from the machine. It would be beside the point if the creeping crab had returned to attack; but whatever may be the outcome, I was ready to give it a tough time.

Music has amazing powers on the mind and body. Socrates once said, "When the soul hears music, it drops its best guard." That, for me, was really one of the highest description of the power that music had. I tried to find that music in the sounds I heard.

50

Through the Foliage of Life

"A withered maple leaf has left its branch and is falling to the ground; its movements resemble those of a butterfly in flight. Isn't it strange? The saddest and deadest of things is yet so like the gayest and most vital of creatures?" ~ Ivan Turgenev

A fallen leaf makes us reason with and reflect on life itself; it also reminds us that everything in life is temporary and entwined in the constant cycle of 'life and death'. A leaf falls because nature wills so. Leaves are infused with magnificent colours just before they loosen from the tree and fall down. They become flush with bright colours and mesmerise us with their alluring rustle in the wind.

The changing colours of the leaf are a reminder of life: that there is a more receptive side to life's changes. They don't change colour on its own, it happens due to the chlorophyll in it revealing the amazing oranges, reds and yellows. Leaves don't make it happen on its own; so are the changes in life. They happen when we are willing to let go of something that is dominant and habitual.

The changing foliage never fails to surprise and delight us. Each of the fallen leaves carries different experiences, colours and meanings throughout life --- showing us to shed our past

inhibitions and doubts as well. It is a symbol of life, graceful aging and death. A leaf changes from being green to orange, red, yellow and finally turns brown and withered; but still not giving up till the day it falls to the ground in death. A tree standing tall in all its splendour with different coloured leaves is a soothing sight to behold. It is one that holds you in awe. It is a perfect example of how to age gracefully with dignity in all its beauty.

The fallen leaves rustle under the feet, smell good and sometimes the wind drives them into a frenzy of dancing shapes. They are useful in many ways. They drift slowly to the ground making a carpet to walk upon. We tread upon the breathtakingly colourful textures: those leaves that beautifully grew old; those that were full of light and colour in their last days.

Sometimes the carpet of fallen leaves looks so delicate when it covers a path or the highways that one mostly hesitates to tread upon it. This carpet acts as protection to the fallen seeds, letting them be till they sprout gently when the time comes. The fallen leaves are of use in different ways, as is life. The leaf and its falling down is an allegory that illustrates the delicate balance of life. Everyone does things differently, look at life differently and deal with seasonal changes differently. We may grow old and wither, but still stand tall and unique in our own way, being useful in every possible way. The fallen leaves, whispers words of wisdom as they rustle in the gently breeze or strong winds, as in real life too.

It is worth contemplating the journey of life and that of a leaf. At one time, all are riding high with clear roads ahead, and yet seeing only unseen obstacles that can stop your forward motion. The leaf, in fact, represents life's changes, struggles, trials, happiness and death. Leaves are more abundant in a particular season; like the opportunities in life. Through the

years of ageing, the experiences help bring about change and guide through a difficult phase of growing up, similar to the leaf which signifies passage of time in life.

Whatever we say or do is a form of our unique expression. The beliefs, preferences, habits, fears and understanding are the leaves of our tree that allow us to interact and commune with the rest of creation. It is this consciousness that gives wings to take efforts for others.

Shapes alter, forms sharpen, and tones become muted. We hear the rustle that makes us look closer. We listen to the whisper of leaves and notice the allure of colours, the constant shift and diffusing of leaves into reds, oranges and yellows. It is the understanding of change that surrounds. We learn to cherish the blaze of energy surrounding us and the captured sunlight on the foliage of life. We learn to bask in the beauty of creation and live every thought and deed of life as unassumingly as the sunlight into the depth of endless space, introspecting the one moment of glow into the vibrant splendour of realization.

The leaves in the changing seasons make us aware of the welcome transformations of life with the passage of time, the power of maturing and acknowledging the ideas and people we value the most. It is the turning of every living moment with the light of awareness, ultimately bursting all the shackles and revealing your unique self with dignity and beauty, before we wither away into nothingness and a no man's world.

51

Raindrops glisten and echo through my memory

"Do you love to run in the rain, splash around and get drenched?"

The onset of rains can always bring a twinkle in the eyes and a smile on your face. The smell of wet soil, damp grass and the feel of puddles under your feet --- they make you want to run in the rain with abandon and feel the drops fall on your face. You want to let the rain caress upon your head, singing a lullaby so that you can experience that joy of feeling drenched to the skin.

Raindrops are refreshing and soothing to your entire being. Rain is one of the most beautiful moments of nature that can enhance you. Nature bestows you with boons in many forms, each different and varying in its beauty. Rain is one of those beautiful moments; it gives you joy and relief as well as consolation and solace in a sad moment or when you are in pain.

A raindrop is one of the most beautiful of natural phenomenon. It is one of earth's most precious gifts. And rain makes everything beautiful. "The sun enables life, the rain grants its safe passage."

On a long drive, watching the raindrops hit the windscreen with a constant patter and tumble away soothes you. Slanted or straight, the raindrops colliding against the windscreen look like liquid crystal beads. They make pretty patterns on the glass and reflect the world around it as they roll off, and that is a beautiful sight to behold.

With each rain your mood could be different: just watch the rain through the window or take a moment to unwind by running through the rain and splash the puddles. Rain might be another moment of love, joy or any emotion. Rain is a companion who lets you share all your emotions with it.

It is truly magnificent when you listen to the fall of rain. The uneven sounds of it pounding hard against the window makes your heart beat faster, and the smell of rain just intoxicates you. It is also refreshing to watch the rain dribble on the windowpane, filling you with a sense of peace as they flow down and make a pool on the sill. When you watch something as pure as rain and you have an imagination to visualise, anything is possible.

When I smell and hear the rain coming, I feel happy from within. It has been so from the time I can remember; so rain also brings a kind of nostalgia with it. I love to get drenched in the rain as it soothes me and takes away all my pain.

It is so refreshing when it pours and when the rain takes rest, the small streams the rain has made in every nook and corner invites to float paper boats in them. I forget myself in the utter joy of splashing in the puddles.

The music made by rain mesmerises me. I would rather smell the rain, taste the raindrops, feel it on my face and see it up close drenching me than watch it staying indoors. When it rains, the childlike spirit in me pulls me into it and my soul cannot resist; it inspires me, heals me and each drop stands for something worthwhile.

Rain and the music it makes lift the inner spirit, inspire and cleanse the body as well as the soul of all its pain. It is motivation, peace, hope --- all rolled into one. I feel all my conflicts and pain dissolving in it and a rainbow of joy encircling around me.

As quoted by H.W. Longfellow, "Into each life some rain must fall." Life gives us sorrow and challenges, which is an inevitable part of life. Rain is a promise of growth and an affirmation of the life ahead with hope.

Every man has troubled times; no one's life is entirely charmed. The only difference is that for some it is a never-ending one. If there is no pain, or life is not threatened, one would never appreciate or know the real value of life, know the fruits of its labour, efforts, sacrifices and the moments of enduring pain.

There is something in the rain that cannot be explained, but you can feel it. All rain lovers have it in their soul. For some an overcast sky may be a gloomy expression of their depression. But the fact is, it is an indicator that pains are short-lived and the rain will fall to heal the pains of the parched soul and body.

It symbolises cleansing away all your troubles to make way for happy tidings. The pitter-patter sound the rain makes is endless and listening to it could be magical. It may sound strange that one goes for a walk in the drizzle when everyone else is trying to stay in, but it is a great joy. Nature looks more beautiful after a downpour. Rain makes you feel alive. Most of all, it makes you love those moments and takes you on a trip down memory lane to all the rainy seasons that you have enjoyed and cherished.

"Gazing at the cloudy sky,
Standing under the heavy downpour,
Getting drenched to the skin,
Flashes of lightening from a thundering sky,

Raindrops falling on my face,
Filling the reservoir of my heart,
Soaking my mind, soothing my soul,
Washing away all my pains,
Infusing a tranquil reflection."

52

Over the Mist of Life

Life is just like the mist that is seen for a while and then completely disappears. So, even when there is mist on your horizon, eventually it will clear and bring light. At times, things don't make sense in life, things that you cannot explain or understand, no matter how hard you try; but have faith that like mist it would vanish. You cannot cling to them or keep them in a treasure box. Some things in life are inevitable; but they come and go like the mist.

However, there are days the same mist is beautiful and fascinating; smaller masterpieces that please the beholder forming clouds of different form and colour. As you look, you see them change into splendid forms and portraying magnificence which is worthy of poetry or painting. You may be enshrouded by mist or clouds that are veiled and beautiful leaving you amazed at its breathtaking beauty. What 'sun' is to the clouds the mist is our 'attitude' towards life. The mist of life can end anywhere, because you are just a whiff of the mist, which catches the light of the sun before it disappears.

Mist is a blurred vision of something real and true in life that cannot be understood; nor is it meant to be understood. It is mystic but natural, more than what can be seen in the horizon and a force that connects everything in life. The

mist disappears as the sun's light enters, painting the sky with beautiful colours and illuminating it with a brightness.

Some of your most magical times of a day could be the early morning, when the whole universe is just waking up; mist covered around you with faint light seeping in and a whiff of cool breeze caressing you. Getting out to see this surrounding nature, enjoy and forget yourself in its beauty could be your way of waking up your soul.

It is bliss to watch different shapes appear from the mist as it hovers around you; it moves in silence on its morning spree. Inhaling that fresh air makes you fresh and alive as the mist shrouds your way with a ghostly glee. There is something strange about the mist, but drifting about in its beauty is magical.

A misty morning is quiet and beautiful with the sun just coming up. It is a joy riding or walking through the mist and then watch the sun's rays clear your path.

53

The paradox of vulnerability
in being positive

I believe in the philosophy of questioning and reasoning whatever comes my way. After that comes the understanding; processing the big 'why' questions and reasoning them to conclusion. I believe there are no 'Unanswerable Questions'. That is the reason why I question myself when others define me. I am surrounded by questions --- why, how, when, what and where.

The thought that I am becoming too sensitive haunted me day and night. Is it vulnerability? Does being positive all the time mean you are not allowed to be vulnerable sometimes? Vulnerability is a part I show to very few people in my life. Isn't it human to be vulnerable? Does it mean that being positive translates into being out of all fears, pains and feelings? Could it be that being vulnerable is a connection to feel at ease? Or is it that I chose to be vulnerable in spite of the positivity?

Despite all this, being accepted with that vulnerability might just be the doorway to affection that gives true strength. We always erect self-protective armour, which few can invade. Awareness of it is a huge step towards courage and strength. When a person unconsciously hurts while being defensive, we are faced with the threat of being vulnerable.

I have been thinking a lot about being positive and being vulnerable. The idea of the word itself: the hard 'V' and its fall and the immediate process of picking itself up again --- there is the relentless part. But what about the compassion that we show to those we hold close? Is vulnerable giving a commitment of providing warm supportive environment, fostering mindfulness and compassion in your relationship with loved ones?

I voice my feelings to a chosen few; those who I think I can show the soft and vulnerable part of me. Yes, being vulnerable involves a lot of risk, but being positive in all circumstances helps squash everything and smile at it; life being a continuous process of learning.

A crab teaches a great lesson in vulnerability. It has an outer skeleton, known as the exoskeleton, which is hard and inflexible, and protects it from an outside attack. However, as the crab grows its shell doesn't grow with it. Ironically, this same protective structure, because of its inflexibility, becomes a ceiling for growth and development. The crab intuitively knows that in order to grow it must back out of its shell. So that's what the crab does.

Similarly, what if you were to outgrow your armour? What could you do or be if you refused to suffocate yourself in your protective shell? It is a thought worth pondering.

When you decide to truly live your life, by discarding your exoskeleton, you too are more open to hurt. All those whys and what-ifs swirling around in your head have to be left alone --- if you want to progress in your new set of challenges. At the same time, stay true to what and who you are.

Transitions are a time of great vulnerability because we do not know what is going to happen and how things might turn out for us; however, there is no growth without vulnerability. Being vulnerable is a temporary state; which, if worked through, can actually make you stronger and tackle some of your most difficult challenges.

54

The tumours of life

Time and again we are told we are what our mind decides to be, we are what we eat ... and many other similar clichés.

I do believe we reap what we sow, but is that what decides our fate? Life is full of uncertainties and the unpredictable. It always takes us unawares. Take for example, "take everything in your stride." Sounds easy, right? Of course, all of us know the power of a positive thought. But, for many thought don't serve at the right time. Yet, we go on thinking, making ourselves confused. And when we think negatively and dwell on it, we allow it to take hold of our life and we become victims of it.

Correcting our minds means stopping them from trying to control our lives, because they never can. They'll only control the misery that we manufacture ourselves from the pain we'll inevitably experience. Much of our misery comes from negative thinking instead of envisaging possible ways of fighting life's battles that come our way and throw us out of balance.

The word tumour creates ripples of fear, irrespective of whether it is benign or malignant. In reality, the fear is the actual tumour. If the fear is replaced by positive will to fight, half your battle is fought and probably won.

It is easier said than done, but that is the best path one can follow to withstand the pain. Fear and anxiety can be crippling

if a positive will is not sought or even encouraged to face the demon with strength and courage. Stop thinking "why me" and perhaps accept that life is not always fair. There is no way to skip what has to be endured. Think of ways to cope with it and manage it; that will strengthen the wish to fight it out.

When we fight the emotional pain caused by the tumour, we get trapped in it. Difficult emotions are destructive and break down the mind, body and spirit. Feelings sometimes get frozen in time; those stuck in them are the victims. It needs a strong will to come out of it. If negative thoughts seep in, the trauma of life can break a person. Be positive against all odds and take it in your stride.

In life there are different types of tumours and they are alarmingly connected to cancer. The disease can be treated and healed with a positive approach to life. But in life there are some stubborn tumours like ego, one that is most fatal and cancerous, the only one that cannot be treated or healed in any way without compromises and sacrifices. It needs an understanding and compassion for each other ... and most importantly empathy for the other.

55

My life with challenges

"We are not given a good life or a bad life. We are given life. And it's up to us to make it good or bad."

"My reaction to these opinions has helped me see that I am maturing, and truly beginning to accept and like who I am."

"Others could no longer break the confidence I had in myself. I could love myself even when others hated me. I was no longer reacting with anger or frustration, only sadness at others' ignorance and their inability to understand and accept that we all are different. In other words, I was beginning to see the advantages of my struggles in life."

"My mother always told me that my condition didn't affect my smiley muscles, don't let them affect yours."

Ward Foley, "THANK MY LUCKY SCARS."

I read these excerpts and quotes in Positive blog. That made me, a rebel, think and reason with myself that how true these saying were. My life had always been one with a lot of obstacles and challenges. And yes, my scars, both psychological and physical, did make me think that nothing can affect me without me allowing it to victimise me. All these taught me a great lesson in life: to only count on the blessings that God sent my way.

I know that it's up to me to be positive regardless of what's happening around me. I don't point fingers and place blame on anyone for what is happening in my life. I realise that everything happens the way it happens; it's up to me to choose how I want to feel about it and that I am in control of my attitude. No one can take that away from me. Whatever happens is a reason to become what I should be in future. To live a positive and joyful life, I should not get affected by negative things that increase my stress level which, in turn, can affect my health.

I learnt that the best thing to do was to focus is on the positive things I had --- working on my blog; cultivating a new and positive role of encouraging those who were going through a trauma, let go of the negative ones. Though it was not easy and, to be honest, is still not so; but I learnt that it's hard to bring out the change in those that we are working on it.

I also realised that I could do a lot to help children out of their confused state of mind. A teacher's experience was enough to do that. Spending time with little children was the most rewarding experience of my life. And with this, I am at peace with my life, thinking I could use my teacher's experience and the trauma I went through as a cancer patient to help anyone who is in need of it.

I have often heard the phrase, "Be yourself." I just love these words and I completely believe that everyone should strive to be the truest version of who they are. I have learnt the hard way that there is nothing more attractive than those who are just so utterly themselves. Being strong-willed, I know what I want, what I am, and I also realise that nobody else can determine my definitions of myself.

I stand up for what I believe, even when others call me over-positive and a perfectionist, because no one has seen my life. Most importantly, I stand up for others where it matters.

This even includes being wrong at times and admitting it. I even open my mind to all possibilities --- seeing the positive in the negative, understanding the behaviour of those who seem to attack me morally, learning from the other side of a passionate debate or knowing when to reject it. I am strong enough to know that I should not be a victim of circumstances.

After having faced so many obstacles and challenges in life, I have learnt to be a warrior. When I shift my mind to the state of being positive, I realise that other people do not control me and that nobody is in charge of how I feel. I am a warrior who makes her life what it is. I am a born fighter; I would like to remain that at all costs.

It is always in adverse situations that I witness my own potential; all the challenges try to threaten my very foundation of being positive. I have always smiled at the face of adversity. Every time, something tries to rob me of my positivity, I make a comeback with renewed strength to face all battles with a smile. Come what may, I know that those who doubt me never knew me and those that know me will never doubt me.

It is not that I never feel down or depressed. I have feelings like any other human being. I too feel hurt. There are times when I have felt small and that the world is crashing around me. It has felt like a tsunami of emotions. While it's happening I feel completely blindsided by it. But even if I stumble, I try to shift my mind to something proactive. I try to channelize my thoughts away from the seeping negativity with a determination. At times, it is very difficult to fight the low feeling, especially when your mind and body are at loggerheads with each other. Then I energise myself with music, or by reading or writing to channelize my thoughts in a positive way.

It's one of life's great ironies that feeling low come to us so naturally. It requires sheer grit and perseverance to stay positive against all odds of life. The challenges and obstacles I have

faced, made me strong and a fighter. The scars of my mind and body do not deter me. In fact it gives me the strength and determination to let go of what I cannot change and face all those challenges with a renewed grit.

56

We can't stop what happens to us, only survive it

Before defining oneself, one needs to introspect about attitudes, actions and behaviours. No one is perfect or spotless. Patience to wait, the drive to keep going, ability for compassion and understanding --- all these come from the experiences one has gone through. Getting the courage to keep oneself up when there are retaliations of all sorts --- especially when life has already been giving enough challenges in life, needs a lot of perseverance and grit. The sarcasm that surrounds one like a cloak, when one is trying to keep stress at bay to fight life's battle every day, cannot be understood by those that are determined to retaliate.

The attitude is entirely one's own making. Actions and decisions taken show the attitude. One is either patient or not; responsible or not --- the only way to change the attitude 'no bother' is by accepting that one cannot help another's attitude, retaliation, or sarcasm, one can only survive it and move on in life.

Being positive and upbeat can influence everyone around, as does negativity. Understanding is a great way to start a journey. Once retaliation commences, it is rarely limited to one or two individuals, it is likely to include close friends and family members, who are shunned, accused of being perfect

and positive. The sheer grit and perseverance, through all the pains and challenges that one goes through, bring about the positive attitude; but the sad truth is, it is often mistaken for being over-positive and perfect.

When one is facing a massive challenge, the best solution is to embrace the situation. When one recognises it to be a trying time and accepts that it cannot be changed, one is no longer prisoner to that situation. Be courageous enough to deal with the challenge ahead the best way one can, without letting stress take charge. Feel thankful for the lessons life taught. One doesn't need to face a life-threatening situation to remind oneself to live more mindfully. Once that is understood, what really matters is the steps one takes to fight out of life's battle.

There is tremendous power in facing adversity. Harness the power and one can survive and thrive through all challenging times, be it a life-saving one. One can succumb to negativity or fight life's battle and ride out the storm with a smile. Much of 'who' one is, depends on 'how' one reacts to situations.

At the end of the day, it is the state of mind that is the key to do what needs to be done, which could even be remain upbeat to fight the battle of life. Everyone needs different things to help stay positive; know oneself, believe and never accept defeat --- that is the state of mind. Remember the best times, let go of all that hurts, and just move on to face the challenging battle of life with a smile.

Facing the hard realities of life and fighting a battle that is traumatic, but the only way to see yourself through these challenges is to stay positive despite all odds. Get motivated by your own journey of life, and believe in yourself and your abilities.

"You may not control all the events that happen to you, but you can decide not to be reduced by them." ~ Maya Angelou.

57

A spectacular ballet of birds in the sky

B irds flying in the evening sky captivate me, creating a flutter in an already racing heart. They form such artistic patterns as they fly. These birds flying in a flock take an emergent character, without any chaos, in flight making gorgeous patterns. The birds come together wheeling, turning and sweeping in unison to create those beautiful formations.

It is a photograph captured in the heart: Like abstracts written across the sky; that of a bird, fish, heart, wave or a geometrical pattern. Just before dusk the birds returning home in flocks is an enticing sight. Each evening, there is a splendid performance of aerial manoeuvres by the bird; it occurs with such spontaneity that it surprises and fills you with joy.

Nature brings forth such perfect artistry that its mesmerizing beauty enthrals me. The birds fly in tight formations making patterns with ease. My daily rendezvous with sunset has been a marvellous experience, watching these birds fly in gay abandon. They make such astonishingly sharp patterns that it leaves me in a wondrous state, oblivious of my surroundings. It is a spectacular display of the flock as they fly home.

Birds' formations are a feast to the eyes as they keep changing every second. I just can't help watching them. They swirl through the sky in magnificent ballet that seems perfectly choreographed. It is a perfect rustle of many pairs of wings, a group dance of birds that is truly amazing. It is a striking ability of the flock to shift shapes as one, reflecting the genius of collective behaviours, something very inspiring.

At first sight, it seems like a moving picture in the sky with their amazing and mind-boggling formations. I am dumbstruck at times, watching the birds suddenly take flight in lovely formations, a spectacular display of sensational patterns. It amazes me to see their artistry in the sky when they fly across the setting sun. I am ever thankful to cancer for bringing back my lost self that can enjoy such simple beauty in nature.

A flock of birds,
Form a rising crescendo,
Up and down, across the sky,
At the onset of dusk.

Like a speck of dust,
To amazing formations,
In a gorgeous way,
Creating a stunning ballet.

Their artistic choreography,
Enthrals me to enslave,
My captivated heart,
With a symphonic flutter.

58

A walk through cancer

Yes, cancer is a lonely journey. Your family and friends are there to encourage you, but your progress depends only on you.

It is a journey that starts from the time you are given the conclusive diagnosis after a needle biopsy. From there starts your long journey. If you have a will to fight, accept it with a smile; your loved ones are then relaxed to a great extent. But if it is only lamenting and complaints from either side, life becomes miserable for both. It is better to accept the fact and move ahead with positive attitude.

The surgery (mastectomy in my case) and following the biopsy report decide your future. Psychologically, it comes as a painful truth that you cease to be a "complete" woman. If you decide to live with that truth with complete acceptance, then you start your journey with a positive attitude. The emotional uplift also depends on your near and dear ones, be it your family or friends.

The most exhausting part of the journey starts with the chemotherapy, depending on the type of cancer. The physical, physiological and psychological changes start there.

It is very easy to coax the patient to eat and advice to be active. You realise the magnitude of pain only when you go through it. Weird taste in the mouth, constantly feeling

nauseated, actually throw up everything you eat, contracting diarrhoea --- all this last for at least a week. Within three weeks of your chemotherapy, hair starts falling. This is the physical effect.

Your taste buds deny any taste in your mouth, still you have to eat. Otherwise your blood count will deceive you. You lose your balance when you walk. It is really an exhausting experience. If you are a fighter, you are able to face it boldly. The support of your family and friends, however, plays a major role. Though you have to face it alone, it helps a lot if you are not taken for granted.

The emotional effect is confusing, sometimes even for the patient. You start laughing over something and you end up crying. Sometimes you feel so low and suddenly you fight that feeling out and smile.

The chemo and radiation saps you of all your energy. You have to take it as a new experience. Smile at the new changes in yourself. The monthly visits to the doctor and your blood tests --- all these have to be faced with a positive attitude, only then can you be a survivor. Otherwise you end up becoming a victim. Fight it with the strength that you have in yourself. And when you emerge out of it, you feel you are refreshed. I compare this to the 'pupa' stage of a caterpillar. Just like the caterpillar undergoes a lot of changes and emerges a beautiful butterfly, you too can come out of your cocoon of the cancer treatment with a positive change in you.

A word of advice for the near and dear ones of a cancer patient or survivor: If the patient has a low spirit and esteem, try to encourage them without complaining. If they have the courage and strength to fight it, don't take them for granted, because the encouragement is still required. However strong they are, take care not to be critical and hurtful, because emotionally they are still at a risk of breaking down, if they are

pushed to the edge. Don't ridicule them. Being understanding is vital.

As a patient, however strong they might be, they are also vulnerable, especially when there is a threat of recurrence or relapse. It is not easy for the patient, or the family members to cope with that threat.

I am able to say this with such confidence because I have taken care of cancer patients --- very close ones --- and have also undergone everything myself. Though I have been strong enough to face it, I, too, have gone through the physical, psychological and emotional pain. There are times when I have felt that I have been pushed to the edge. Still I am positive, even after going through a lot of emotional pain given by others. Only a person, who has undergone some kind of pain, can understand how it is to be in pain. Do not judge, ridicule or push those who are fighting this battle.

Try to support, encourage and inspire them with a bit of understanding and consideration. Do not slice them with words. Sometimes they become silent due to that anguish. Help them keep up their smile and positive attitude.

A candle loses nothing by lighting a candle. Be a candle to light and inspire another life. Be a candle of hope. Be a spark to ignite and inspire someone who needs that little spark to which it can hold on.

59

The irony of a woman's life

"It is fate" and "It is destiny" are phrases heard quite often. But for me, I have always questioned the challenges that fate hurled at me. I was always the rebel who questioned all the lines drawn only for women in this society. Sometimes it is a sad quirk of life indeed, that being a woman you feel lost; especially when mindset and comments of common people come as a slap on the face.

Something verbal or a situational irony renders one helpless; as for me, my instinct was to slap, with all my might, the faces of those two well-dressed men. But, at the last moment a thought held me back: I would be making myself impure by touching those scoundrels.

What is beauty? A beautiful face? A well shaped body? A beautiful bust? Are these the only measuring scale for woman's attractiveness?

It is ironical that these two were standing behind me, in a queue at a counter, commenting; perhaps mistaking me to be a young woman: it could be because of my short hair or they didn't notice my greys or it didn't matter what age a woman is. Little did I realise that their comments were targeting me. Only when I turned around to pay at the counter, I heard the comment, "Hey, she has nothing in front."

Although my first instinct was to take slippers to their and ask them if they had no women folk at home, I just gave them a dirty, cold stare and walked away. But my skin was burning after hearing all they had said.

I have never bothered about my appearance: when I shaved my head, lost a breast, or ended up with no breast. I would say they served their purpose and were gone.

I could have bought false breasts and tucked them inside and walked about as if nothing had happened. But, I am not made that way so I didn't bother about anything. However, after this incident, the two animals --- who would roughly be my son's age --- showing disrespect to women is too much for me to take. I still am not bothered about my appearance or 'feminine' beauty. I was, I am and I always will be what I am.

It is generally believed that a truly beautiful woman is physically appealing; it is an irony of life that such is the society where physical beauty is bestowed such a high degree of importance, but the confusion will be whether the real beauty is in the face or the body?

I feel a woman should also be admired for the inner beauty as she revels in staying within the boundaries put on around her, all her life. Her inner spark makes a woman glow. It is not in the clothes; true beauty is revealed in the eyes and reflected in the soul. It is in her caring ways, which grows within over the passing years as she ages gracefully.

I have always hated men who never look at a woman's face but elsewhere while they talk with them. Whether a woman is complete or not, there is a glow in everything about her; looking feminine is the key. I have always valued the respect I have been given as a woman --- at home as well as outside with a line of dignity that I never crossed. It takes a lifetime to be respected, but a split of a second is enough for that respect to crash all around.

What is this feeling?
That rushes through me,
Unveiling my capabilities,
Like a fine intricate lace.

A smouldering power,
Still ignites a burning,
Longing for something,
To fulfil my aching heart.

A heat penetrates,
Through the veins,
Spreading through my body,
And then cools the soul.

Like the venom surging,
To kill the monster,
That robbed me off,
The so-called feminine beauty.

But my will is stronger,
Than any maladies,
Or insulting comments,
That can take away my positive glow.

60

Cancer a Killer or a Life Saver?

Cancer is called the 'Emperor of Maladies.' It comes in many ways, many forms and in different parts of the body. Where it attacks is unknown. It is astonishing that one multiplying cell can make a person end up in a storm of anxiety.

However, when the cancer attacks, it makes one realise the value of life and living its full potential. It makes you fall in love with yourself in a very unique way. Though it gifts you with a lot of pain, it makes you realise that the pain is the one that keeps you alive.

The rapport and understanding that I have witnessed between cancer patients and survivors is immense. Perhaps it is because they understand what the pain is and what it is to be threatened with an illness that has the power to overwhelm you if you are not willing to give it a fight. They have a smile of understanding for each other, which is a rare sight in everyday life.

Each patient or survivor feels it is a ghost of a cell in the body that mutates and threatens from behind dark curtains. I have heard many of them say and pray that it is a disease that no one should get. It could be because they know the trauma of going through all the treatment and facing all the pains associated with it.

Today, again I mused over the irony of life. Technicians at a diagnostic centre, which might have seen innumerable cancer patients and survivors every day, are surprised at the quirk of fate gifted to me: a bilateral mastectomy.

I was amused at the thought of having an IV set on my leg --- according to their protocol, blood should not be drawn from the arms of a woman with bilateral mastectomy --- but they preferred to fix it on the side that was operated upon first. Talking with me, some of those waiting in line were surprised that I had three surgeries for cancer in three years; most of them had come for a routine scan. One man even told me, "Probably cancer has fallen in love with you." I smiled at that because I always say that to everyone.

Cancer was the best thing that happened to me because I got back my lost self who was always one with nature. It gave me the time to do all that I had kept aside in my daily toil. In spite of everything I feel blessed in many ways. I had the will to endure and celebrate my pain; make it a beautiful one that even today keeps me alive. I live with a bounce in my step, a song in my heart, a burning fire in my soul and a beaming smile on my face.

61

The fly or die attitude

Even the greatest, most powerful and most positive people have their weak moments. There is a time when you need to push yourself and stretch your wings to soar high. If you never stretch at such a time, you will never fly in life. You can learn a great lesson of life from birds around you. Among birds eagles are symbols of strength, bravery, courage and great independence. Being strong and positive does not mean that you will never get hurt, but it just means that when you do get hurt, you will never give up or let it defeat you. You become stronger than what tried to pull you down.

Freeing yourself from all the clustered doubts and thoughts is not very easy, but you have to do it to be who you are; to fight the negativity that tries to seep in. The birds always inspire and are messengers of life. A nest is a safety zone of comfort, so are favourable conditions of life. But if you are always made to face the unknown and fight challenges, then you find that the unknown is an experience that makes you what you are. You never know your strength when you are only in a comfort zone. When you are facing the unknown only you learn to grow and live life fully.

A young bird is often pushed out of the nest to learn the strength of its wings to make it fly. A fledgling-a baby bird that has some feathers, hops around and almost ready to fly,

is pushed out of the nest to help them learn how to fly. So are the challenges that come into your lives, they make you realise how strong you are and you need to push yourself, to fly out of all adversities. It is a FLY or DIE situation, if you want to fly you have to fight it out, but if you succumb to it, you die.

When I was working as a teacher, the School premise was such that created oneness with nature. I used to watch with fascination, birds make their nest with things available to them, the eggs, hatching, feeding by mother birds and when they were old enough, the push of the mother bird, to make them fly. The first time it was pushed, it kept going down and then it flapped its wings, and the mother bird picked it up to the nest, till finally it flapped and flew away. It was an experience and a lesson I learned. Birds always inspired me to ponder on life.

What made me contemplate on all this is the breathtaking flight of birds in the evening. It was drizzling and I lifted my face towards the sky to feel the raindrops on my face. The sight of a flock of small birds, black with a stripe on their long tail feathers, flying in the shape of a heart made me gaze at them awe struck. As they were flying in gay abandon, they changed patterns from a heart to a wave, then a line and finally to a V formation. I was really in a trance watching them and feeling inspired. Like a man, it has such beautiful mysteries.

You need to know your inner potential, trust in your talents and creativity, and fight all challenges life throws at you time and again, spread your wings, soar and fly high like a majestic bird. You may crash many times but the more you get up and come out of it, the sooner you will be soaring back to life. Only you can push yourself, to stretch your wings and fly high in life by challenging the very core of life itself. Even in solitude, a bird sings the most beautiful melody of life.

There are beautiful insights that you learn from a bird about life. What I have always pondered is, not to feel ashamed to learn from others, not to get affected when others crap about you by being nasty, not to feel burdened and weighed down by the struggles and pains of day to day life and that you have the strength and courage to flap away with a smile. A bird can teach you that it is easy to build a house, but you owe it to yourself to always make a home, be happy with what you have and always learn to keep a happy balance in life. I value spending some time in solitude. Birds enthral me.

"Be like the bird, pausing in her flight on boughs too slight, feels them give way beneath her, and yet sings, knowing that she hath wings." Victor Hugo.

62

Dare to face every challenge and rise like a Phoenix

Life after cancer means making some new choices: facing new challenges, valuing your life more, and waking up to the fact that you deserve to do what you love. You discover new things and realise it is a fight for life, through life through grit, determination and perseverance, and that the fight is never over. It is only at the end of your treatment, your journey of real fight starts. You really embark on another leg of your journey. It is adjusting to a lot of changes in your body, a fight with yourself mentally and looking up to squash the new challenges that crop up in your path.

After your body has been through an enormous assault by the Emperor of maladies, recovery is a huge thing that depends only on you. You are going to bounce back, though not immediately. You are hit time and again throwing you down, either with a catapult of the after effect of the treatment or new threats from the creeping crab itself, that makes your life worth fighting for, to dare and challenge it, making you feel victorious and not a victim. The treatment may even have cognitive changes of thinking, remembering or processing that affect many aspects of life. Cancer is not a death sentence, it is a journey of life that 'can' make you a survivor; who is always

a warrior fighting out the challenges the emperor of maladies sends your way to take care of yourself.

Sometimes I feel it is an awakening of your 'self' to take care and keep fighting, whatever it is that you are dealt with. The heart says I am beating for you, love me. The weakening of your muscles, tissues, ligaments and bones tell you to keep yourself fit and happy. Fight for that twinkle in your eyes that threaten to dwindle and dare to keep them alive. A survivor's armour is the nutrition and exercise to keep yourself fit, in spite of all the challenges hurled at you. It reminds you to feed your specific needs of life. Wouldn't it be a shame to weaken after having fought the battle of cancer?

Life after cancer can sometimes be long and arduous path, with many challenges cropping up to weaken the body and mind. The treatment and the fight sometimes heighten a sense of vulnerability that creates confusion. At times effects of treatment doesn't stop with the end of treatment, but manifests itself in the journey after the treatment. It is only a never give up attitude that can keep your fight alive and your courage to challenge it leads you out of the tunnel of pain. It is always a new learning experience of life to fight life.

"Dare to face every challenge and rise like the Phoenix."

63

An Unforeseen Bond

B onding is simple enough, but not always easy; it can happen but may not; and, as wondrous as it is, it is also unexplained in many ways. Sometimes there seems to be a deep, unexplainable connection, which leaves us confused. It may be an instant bonding which leaves us asking why, what and when, we feel as if it is a feeling of knowing someone with our heart and soul; from the past life. It cannot be explained in words, it is a feeling that leaves us with a train of thoughts.

It is an unseen one, who has touched your heart and soul, in many ways. Someone whom you have not looked into the face, but been embraced by warmth of their being. An unseen friend whose eyes can gaze at the heart and soul, and you are left in awe and wonder. One whom you can feel like a welcome breeze that comes to give you solace on a hot summer day, life a whiff of mist that surrounds to soothe the raging fire in the heart.

When we sometimes get acquainted, we feel that there is something that attracts you to a person. There is no explanation to that feeling. It is said that if you are able to explain, it is just a liking.....because you like something in that person. But a pure affection and care has no explanation. It has no relevance to distance or age. You just find happiness in their happiness, a

care and warmth so special that they become a part of your day to day life. The little things you do give immense happiness.

Time mysteriously takes you to the threshold of missing another, leaving you flabbergasted at the unseen bond. An unseen bond, that's for keeps, as you feel that they have become a member of your family. Someone that time brought from nowhere, and leaves you wondering about it. It is someone who has become a part of you. It is a bond from nowhere, of solely the heart and the soul, which gives you peace and tranquillity, like that of a long lost son and mother.

64

An enhanced bond of life

A strong bond is not always a balanced equation. It is reaching out to someone whom you have never met and making them a part of your life's journey. It has neither explanations nor any reasoning; they just become a part of your well being and family. It is not predestined, it just happens out of the blue. They become a part and parcel of the family. It is strange but true.

It is an unseen bond, which enhances our life in a positive way, wondering at how it happens. You get strangely acquainted, feel peaceful thinking about them and feel an unreasonable affection towards them that cannot be understood. Sometimes it is a question in our minds, if such a bond is possible, an unconditional bond, wherein you think only of the well being of that person and the people around their life. You are willing to sacrifice anything to keep them happy. It could be an attachment of the previous life, or a cord of attachment that was predestined.

It may be a world opening up to heal and a bond that solely fosters on the mutual care and affection. I feel it a bond that attracts you for no apparent reason and becomes mutual warmth. Life sometimes brings such people into your lives that are not blood related, but become an inseparable part of your life. This has no explanation as to why, what, how, where

and when. But you miss the presence and absence. It is a bond that actually makes things happen, it is a very sacred thing for those who reflect on their life and see, contemplate and feel on what's happening; wonder at what the spotlight is illuminating in their life and relationship.

Fate sometimes brings you someone who becomes a vital part of your life. A life saving, genuine, loving bond, for whom you wish only the best in life. It is a bond where you are willing to give up anything for the welfare and bright future of that person, expecting nothing in return. You give your heart and soul for that bond, an unforeseen bond that came from nowhere like a melodious lullaby to soothe a mother's heart, not really knowing what you have become to them, but knowing that they are an inseparable part of life. It is a blessing and a life enhancer.

"We do not remember days, we remember moments. Too often we try to accomplish something big without realizing that the greatest part of life is made up of the little things." This bond is not a little thing for me, but a vital part of my life.

65

A Sweet Awakening

"Your body is precious. It is your vehicle for awakening. Treat it with care." ~ Buddha.

I was suddenly awakened to a point of retrospection, and that left me flabbergasted at the revelation that I took life for granted. Cancer came as a thunderbolt from the blue, and awakened me to the fact that I needed to go slow and also taught me to take care of my life, do the little things I really wanted to do. This awakening seemed to happen when I filtered my limits, waking up to a wider reality to the person I was once and who I had become. There was no apparent reason, but maybe I felt the real value of life when my body got invaded by the creeping crab. My heart and soul woke up to the bitter truth that brought me to my knees.

It was like welcoming a new lease of life given, reawakening my soul to all the passions of my life. It was a new springtime of life, and that gave me the gift of new meaning in life. All my heartaches of yesteryears disappeared into some remote area of my soul as I treasured my love for nature. It brought me a treasure of memories and little gifts with the passage of time. Gratitude nourished my empty heart and soul for the sweet awakening. I started looking forward to all the little joys that life bestowed on me and valued them all the more than

I did before. Gratefulness was aplenty when I looked beyond myself to see the beauty that existed around me in nature. It brought back my nature-loving self, the one who found joy in the dewdrops, raindrops and the simple beauties of nature.

A gentle rush of feelings
Can send shivers down the spine,
With an awakening on wings of fire,
In the heart and soul,
Feeling specially sweet,
When life is at stake.

Heart sings again with a warmth
Soaring so high in the sky
With a gift of unchaining
A stolen soul of yesteryear,
Feeling thankful
For the new springtime.

66

Lo and Behold, is Your Favourite City Adversity?

S omeone close to me once told me that my favourite city is adversity. Yes. In a way it is really true, because it is never a comfort zone. We are always facing the unknown, no matter what. It is in the face of adversity, we really learn how to live. We learn to face everything with courage and we gain the strength needed, from nowhere. We learn to face challenges. I read somewhere a quote that a challenge becomes an obstacle, only when we bow down to it. It is very true, because as long as we are able to face a challenge, it is never an obstacle. We have to make up our mind that we are not going to be beaten by the situation we are in. It is the will to face any challenge that makes our journey of life a fruitful one.

Life is beautiful and worth living, when we have confronted all the challenges and come out triumphantly with a smile, telling the world, "Look I have come out of this, try me more if you want." If life gives happiness, it is a blessing. But if it is pain, go through it with every atom of endurance.. It is no use wallowing in self pity or cribbing about our fate, because once we give in to self pity; we are killing ourselves, a kind of suicide. When we receive blessings, we never ask, "Why me?" But when we are faced with challenges we fret and fume.

I have learnt a lot the hard way. I find new joy, when I overcome each challenge thrown at me. I cannot change anything that happens to me. But I sure can change my attitude to what is happening to me. Life after cancer has changed my priorities. I love life and I try to use every moment of it, to do something that gives me immense joy. It may be a challenge to help someone, inspire someone or just be with someone who needs that wee bit of inspiration. I have realised what matters to me and what doesn't. Probably cancer taught me that "you live only once and to make the most of it, while you can."

Even when I get into a tight place and everything goes against me, till it seems as though I could not hang on a minute longer, I have not given up on hope. Nor my will to never ever give up, because sometimes it is that place and time the tide will change and gain new strength to fight on. Challenges cannot define me nor beat me. I love to smile even in pain. When life tries to kick me, I give a broader smile to kick it back. I have always accepted the inevitable, and perhaps that is what keeps me going. Each time I overcome a challenge, it is a beautiful feeling of victory, because today I cannot resist a challenge.

"Challenges are what make life interesting; overcoming them is what makes life meaningful."

67

Fulfilment of Womanhood

A woman is a daughter, sister, wife, mother and grandmother. It is a remarkable blessing to be born as a daughter. The happiest moment of a woman's life is to become a mother. It is a moment of pride for any woman, a fruitful moment for all the pain that she goes through. It is a time to bask in the glory of motherhood, after all the small sacrifices and pains that she went through. She finds happiness in watching the growth of the baby, in all walks of life. She finds immense joy in their achievements, gives unconditional support in their little fears and failures. A tower of strength to the family, whatever happens and a store house of moral support.

Another moment of pride and joy is when her children make her a grandmother. It is a walk down the memory lane, for her to cherish the memories of her motherhood. A bundle of joy to enjoy the last stages of life, just watching them grow up, pampering them and their little fancies, telling them stories, satisfying their inquiries and playing with them. Putting them to sleep, singing the same lullabies that was sung years back to make her children sleep. It is also a journey down the memory lane, when the child she held so close to her heart, becomes a parent. A realization of how time fled past her very eyes, sometimes watching their little mischief and

pranks. Sometimes it meant missing out on those important times of life, a milestone. But it is a time to reminisce of those bygone days.

In the end, it is a fulfilment of her womanhood. It is a completion of the beautiful cycle of life. A moment that gives immense joy, to hold that bundle of joy, that makes her life complete.

68

The Oceanic Mind

Standing by the beach waiting for the sun to rise from the horizon, reflecting on how it eases the mind and heals the body, I realised that the sea level had risen, a common sight after the tsunami. Due to the rising sea level the beach sand had formed a slope of its own. Early mornings usually the sea is calm and tranquil; all the morning walkers would stand or walk on the wet sand The last two days, I noticed that the sea was not calm as it used to be always. The waves were moving in more than the usual level.

This morning the waves were sending everyone scrambling up as they were careful not to wet their shoes. Even those who had come to watch the sunrise enjoying the waves teasing them were standing at a safe distance. I too ran back thrice when the waves took me unawares. As the waves came above the slope I saw little crabs scampering away from the waves. The sandy beach was full of little crabs scurrying about. The swell of waves left a lot of ripples and bubbles on the sand as they receded giving a lacy touch on the beach.

I removed my shoes and ventured a little into the beach, but at a safe distance and dug my toes into the sand, watching the waves repeat one after another. I stood there contemplating on the fact that the ocean and the mind are so much alike. The usual morning sea that used to be calm and serene was

not so. The peace I felt at the first touch of the waves on my toes was not there wondering what made the sea level rise? The serenity that knows how to make each one feel at ease, filled with peace was missing. I reflected upon those days when I used to make sand castles and waited for the waves to wash them off.

When the sea was rising up with its playful waves everyone around stayed away from it. I mused over that thinking how even man avoided one who was furious, agitated, confused or one who was not in the usual frame of mind. Even those that look up to that one person in awe stays away. The mind and the ocean that stays calm, sometimes is avoided when there is an absence of tranquillity. I had read that each drop of water expands a little and the expansion of the entire depth of the ocean adds up and causes the sea level to rise. Today it is rising due to the melting glaciers too. Just as the rising sea level is a threat, so is the perplexity of the mind. Each little thought, the doubts, misapprehensions, fears if allowed to grow the level of anxiety grows even in a calm mind. Even the most calm and positive person can become in a state of confusion. The external conditions around you are like the melting glaciers that can cause havoc after a point of time, when your limit of endurance wears off. A mind that is in turmoil causes lot of problems to oneself and to others too.

The ocean fascinates me, inspires and there is an innate relationship that goes way deeper each day. A wave coming out of the sea in repetition captivates the heart and mind. The wave ebbs and flows across the sand; its untouchable vastness and depth, is notable. But one thing that transfixes me like nothing else is the power and peace of the ocean. So is the mind of a man, reflecting the perfect portrayal of a paradox, It is both mighty and tranquil, aggressive and calm, also enraged and at rest. One moment you feel the power of the waves as

they crash, the water drops sprinkling on the face and the next moment you also feel the gentle kiss of the waves on the toes quickly receding back into the sea making you dig your toes further into the sand. It is a mystery to the unknown.

69

The conundrum of a biological micro machine

"The body is an instrument which only gives off music when it is used as a body." ~ Anaïs Nin

The body gives music only when it is in rhythm --- of your heart beats, of the bounce in your steps --- even though music can heal your body. Your body is actually a biological machine. I find it difficult to think of another asset that is more important than your own body. But, it is also a machine that needs to be taken care of like anything else: think of it as a car that is a timeless classic and your prized possession. Over a period of time, even this biological machine may breakdown or become sluggish if its maintenance is neglected.

When your body works overtime, it becomes much more difficult to repair it as the wear and tear could very well lead to permanent damage. As you live your life, you do not think of the reliability or longevity or quality of your body. It could be due to complacence or negligence.

But you have to ensure that your body receives the best possible nutrition, exercise and relaxation to keep it fit; give importance to its needs. Unfortunately we all tend to ignore

our biological machine. There is no miracle pill to keep it working without a hitch; it only requires the basic balanced diet, ample fluids, enough rest and exercise. Your body is not designed to be inactive. Wake up and realise that health is your most important asset.

The day you find yourself taking more pills than your food, you can be rest assured that you have abused and overused your body, or you have been lethargic to use your body properly. Either way you suffer.

Even with the best care given to this biological machine, sometimes a disease like cancer and its strong treatment affects every tiny cell or organ. Still all is not lost. You can fight that by pampering yourself with nutrients and exercise your body to be strengthened. Become your own body's mechanic and fill it up with the fuel it requires, carefully watching what you refill it up with. Your body will thank you.

Your fight for survival will inspire and motivate you to move ahead and take care of your biological machine, to face the challenges any malady can gift you. Like any other machine, everything is inter-connected. Sometimes, it is the genetics that tend to ruin the machine. When it comes to the complexity of the functioning of all organs in tandem, it is human nature to think it may not happen to you; that you are immune to everything, but the care you took of your body and the choices you made have a dramatic effect in the long-term. Life is forever a fight for survival, taking care of your health while you can and the best way you can.

70

The gifted creativity of life

"I believe talent is like electricity. We don't understand electricity. We don't use it. You can plug into it and light up a lamp, keep a heart pump going, light a cathedral or you can electrocute a person with it." ~Maya Angelou.

Talent might be inborn, but creativity is a skill. Even if one has inborn talent, one has to reach out and take it. That taking may be as difficult as not waiting until it manifests on its own. It is the underlying passion, a feeling inside that is loaded with words and a lot of meaning. It is long patience, an effort and intense observation that flows out. Talent is having a fountain of words in the mind. Not everyone has an underlying talent and rare is the courage to follow that talent and make it creative.

Talent is always on its own level, which rises like the sun, rested, refreshed and ready to dawn; always full and aplenty with new treasures. Those that are genuinely talented are unaware of their own ability and potential. It has its own increases and decreases, like everything that breathes. As Sophia Loren quotes, "There is a fountain of youth: It is in your mind, your talents, the creativity you bring in your life and the lives of people you love."

Writing is a play of words, adeptly placed and turns out to be either a prose or a poem. Writing a poem is an inborn

talent and a poem is usually a whisper, a shout, thoughts turned inside out, a laugh, a sigh, an echo passing by, a rhythm, a rhyme, a moment caught in time, a fear, an anguish, an epitome, an euphoria, or a glimpse of who you are. It is often like a spider's web beautifully spun with words of wonder, with all the woven laces that is held in place by the whispers of the heart. The depth and meaning of a true poem lies in the intricately placed words and the spirit between the lines.

Gifted is a man who has the innate ability to do a particular thing, it is talent inborn; one can really never change it because it is fixed inside and cannot be lost. Creativity is a skill to write or create something in a unique way. As the saying goes" Eyes that look are common, but eyes that see are rare." It is a rare eye that sees and captures those that are realistic and natural. The creativity is a skill that can be developed with experience, and experience is a knowledge one gains through grit and perseverance. There is a strong relationship between talented, creativity and experience.

Some just blow up their talent and passion; while some use their talent to connect to everything around them with creativity and experience it. Be it writing, photography, painting or any form of art and craft, it is the passion and the underlying inborn talent that makes them creative and experience makes them excel. While talent is inborn, creativity is an ability that needs to be noticed, recognised and nurtured to bloom. It is an opportunity for the creative talent to be expressed. It is the characteristics of creative talent to be curious, persistent, and metaphorical and open to ideas.

Only a gifted man can play with words and bring forth what is in the mind. It is creative talent that bleeds from the pen, in the form of chords that tug the heart, create a flutter, touch the soul to ponder over or dive into its depth to sink and then float in them. It lingers on in your heart, mind and

soul to haunt, provoke thoughts, contemplate or inspire. The command over the language and the expertise to use it the right way is an added ability to the creativity of talent.

Creativity is a mind skill that equips a man in any area. What matters more is to make use of the gifted talent to create, a natural ability and flair to make something that is beautiful. The beauty is developing analytic, creative and practical skills without the 'know-how's' and that comes out of a gifted talent and the zest to be creative. Life as such is creative in all its forms. It is a gift of life to be born talented, becoming creative is an added skill and experience adds beauty to everything.

"Use what talents you possess. The woods would be silent if no birds sang there except those that sang best." ~ Henry Van Dyke.

> Believe in the underlying talent,
> Create the unbelievable masterpiece,
> Challenge all hurdles,
> Shine like the sun,
> That your name depicts.
>
> Burst out through the clouds,
> With worded rays,
> That shrouds in cluttered clusters,
> In the depth of yours,
> The heart and soul.
>
> Be reminded of your infinite potential,
> With the pen that is mightier than the sword,
> Let thoughts always flow out,
> To reach the expanse of the sky,
> And reach greater heights of life."

71

Pave your own path with a smile

In the new crossroad of life, take the path less travelled and make a difference in life. Make use of your talent and creativity to create the best experience of life. You are the master key to 'YOU'. Believe in yourself and be yourself. Keep a positive attitude, take up all hurdles as a challenge and keep going forward. Your determination and perseverance is what makes you unique and special. Reason with the mind all that your heart dictates and create a balance. Ignore all negativity, explore and achieve. Time has the greatest power. You have to aim to accomplish what you crave for, pursue those that you love doing and then do them so well that you 'Stand Out' and shine.

Believe that you can excel in every field, with a positive influence, never bowing down to the challenges and pressures of life. Attitude and influence can be compared to a liquid that flows into and out of all of us. Character is what flows into you directly affecting what flows out with a great impact. Aspire to inspire and meet all challenges; motivate yourself to reach the highest peak of life. Life is a continual flow of learning and teaching. Always accept the concept of abundance and purity instead of deficiency and toxicity. You have the power within you to be something amazing.

Do your best always. And fulfil all your dreams.

Aim for the expanse of the sky,
Reach out for the impossible,
Be humble and simple,
As your name depicts.
Stand tall to cut through,
All clouds of doubts,
Believe in your ability,
To glow each day.

Always be the little angel,
Open deeper potentials
Within your heart and soul,
And shine forth with a smile.

72

The yearning of a heart when the crab creeps in

When cancer attacks, there is a feeling of uncertainty and confusion of emotions that come to the forefront. Sometimes it rattles the one going through the trauma of the treatment. There is a craving for understanding throughout the journey.

I realised during the trauma of my treatment that love comes in many forms...by way of true friendship, from family or strangers. It is also thoughtfulness at your time of need, a warm hug or a word of appreciation. The only question is whether you are able to recognise it in its truest and purest sense to really receive it. You grow up with a lot of fantasy about love and also live in that fantasy till you die. When I contemplate now on what really love is, I feel it is a belief in a person's potential, it is being present with them in the sorrows and joys, treating them with empathy and giving them ample space to grow with a strong bond, not of obsessive possessiveness or demands, but one of care and warmth with freedom.

The word love may have different meaning to each individual, but it is a word with a very powerful meaning. This word applies to your love of your parents, siblings, offspring,

spouse, friends, etc., so love is a feeling or an emotion or a state of mind of a human. You can give different meanings for the word love. For some it is the true inner joy, the one bounded by the soul. For some it is the care and affection. Though it sounds simple it is equally complicated and it can sometimes be confusing and messy. Love isn't always selfless, patient, kind or trusting. Sometimes you are so busy looking for love elsewhere; you don't open your eyes and heart to see it around.

It is a gift of authenticity, by understanding, seeing, hearing, accepting and the secret of true love is to allow the other to grow. I also learned that love is a yearning for others to be happy even if I am not a part of it, hoping that I am someone who is like that to all I love. I learned that love is not trying to own a person.

> Love is always magical,
> Not found in prescriptions,
> Nor the cannula,
> It brings sparkle in the eyes,
> Instils hope in the heart,
> Awakens passion in soul,
> Dissipates gnawing pain,
> Brings out an amazing smile,
> With strength unknown,
> To fight for survival,
> Ceasing the heartaches,
> As life goes on and on.

73

Love for Cancer

"Cancers are all alike"

This is a truth that no one can deny. Cancer is called the 'Emperor of Maladies', and rightly so. You never know where it will attack, or how. It is different for each individual; so is the pain. Anyone who has endured a journey with the creeping crab will narrate a different story. Yet, every story will be bound by the commonalities of pain, perseverance, resilience and victories. It is a known truth that everyone responds differently to cancer, its pains and the treatments.

Once creeping crab attacks, you realize the beauty of life and the joy of living in the moment. It inspires you to find meaning in your life and to appreciate the magical moments. You start understanding that every flower, every falling leaf and everything else around you has a soul. Every moment is etched in your heart and soul. Even the endless pain makes you value every second of life.

Is the experience the same for everyone who has had to face off with this loving monster? The answer is a resounding, "No!" The effects and after-effects depend on each one's body and how hard you fight it. Some people just give in, knowing that it is an endless fight for life.

This fight makes you aware of the beauty that is not physical, but that which comes from inner power and strength and radiates a positive glow on your face. In this whole process, it is an understanding that takes you forward. Any kind of stress can trigger it again. When you go through the trauma of bilateral triple negative cancer and its long term after effects, you begin to love the daily pain, since it is a reminder that you are still alive. They say there is no magic pill for the long-term effects of cancer treatment, except exercise and good nutritional food to keep up the quality of life. Then, as they say, "How you deal with it is all in the mind." It is a daily fight and that keeps you going with a smile, joy in the heart and a bounce in your step.

Cancer invades uninvited and unwanted,
An intruder in my body,
Waiting to claim me,
A complete stranger though,
It weaves a web of intricate pain.

Like tsunami my chemo,
Unleashes its power,
In each of its cycles,
Leaving me in a hazy maze,
With its long-time after-effects.

I enter the battlefield in fury,
The scans and labs a learning step,
To score a goal against the monster,
Finding the essence of life,
In my inner sanctum.

74

Bonding is like flying a kite

Standing on the beach with my toes dug deep into the sand, the waves playfully teasing me by tickling my feet, I turned to catch a glimpse of the setting sun. The sight of a huge and beautiful paper kite, flying high in the sea breeze, left me awe-struck. I just chuckled to myself thinking what could be more fun than watching a kite on the beach, the cool breeze making it dance to its tunes. The young fliers were carefully flying it against the wind and birds.

I felt a special joy in my heart just looking at the kite. It was flying so happily in the open space, despite the turbulence all around. It was the open space --- which gave it a lot of room to fly in accordance with its will --- that made it soar high in the sky. There were no obstacles and the fliers were carefully manoeuvring it, leaving enough length of the string that held it. As I gazed at it, as suddenly as if I had been slapped really hard, I realized that every bond you hold close to your heart is like that kite, be it your spouse, kids or friends.

Sometimes, you tend to overlook certain aspects of your bonds in life, in word and action. Just like the kite it stays attached only if it has enough space to exert its own free will. It needs the wind to stay afloat. But the minute you try to control it too much, by tugging on the string, possibilities are high that either it might get cut or the kite might cut itself due

to the turbulence. This was a great revelation, a new lesson I learned from the kite. I learned that a kite is like any bond that you hold close, taking care when something goes wrong or the kite flies far away from your view lost forever. An irony that is hard to accept in life and the bonds you foster.

75

Mother Nature, the greatest teacher

Nature has its own ways of making you aware of its importance. Everything around you in nature is a metaphor. Nature has always been an inspiration to poets and writers. I have always been close to nature. However, somewhere in the rat race of life, I had stopped appreciating the small things of beauty around me. Cancer again took me back to nature, which has been a great solace and healer. The floating clouds and their patterns, the flying birds, the flowing streams, the trees, the blooming flowers, the blowing wind, the twinkling stars, the rising sun, the shining full moon, the rolling waves, the towering hills, the falling leaves and the setting sun are all different forms of beauty that connect in many ways. Nature teaches the value of innocence and gives lessons on the same, too.

Nature, the greatest force in the universe, reveals itself in different concrete forms --- mountains, rocks, oceans, rivers, trees, etc. Mountains, hills and rocks teach us the value of perseverance. They have been standing tall for ages and this steadfast position is a lesson on how to stand your ground for the right and against the wrong with our heads held high. The human mind is as deep and mysterious as an ocean. Love,

joy, kindness and mercy reside in the depths of each heart; even pearls are found in the floor of the bottomless oceans. The journey of a river from its source to its destination is a life lesson on how to brave the odds by means of willpower. A river also teaches us to stay within our boundaries in order to be respected and revered, and that breaching boundaries can cause a flood. The tempo of human life never ceases, even in the face of adversity, just as rivers stop at nothing on their way.

Flowers spread fragrance, teaching you to love unconditionally. Trees exist despite unfavourable circumstances. As you grow and age, innocence is replaced by experience. Such are the changing seasons of nature to making you feel and exist. To be precise, the extreme forces of nature give lessons on adversity and survival. It is this world of nature where I fly to, leaving the monotony of day-to-day life behind. The hill, the seaside, the lush green fields and the canals that are added beauty to a village, the trees by the fields, the simple reflections you see in the water --- all these lend me a new lease of life through rejuvenation of the body, the mind, the soul and the senses. If there were no retreat to nature, I feel it would have been very difficult to feel alive. Spending time with nature is the best escape, however temporary, from such grim slices of mundane life. It is the best way to revive your energy and enthusiasm.

Nature teaches us not to play with it to such an extent that we are forced to experience its wrath. However advanced our technology, and however much we humans play with nature, the fury of its devastation is so enormous and happens so quickly that we don't have time to even think. It is said that you should have the patience of Mother Earth, but even this patience wears off and results in the periodic calamities that serve as reminders to respect it. Mother Earth teaches you to never push anyone to the edge and test his or her patience as

the effects of such actions may be devastating to both parties involved.

The beauty of hills, seas, waterfalls, lakes and the starry sky has been the Muse to many writers, poets and painters. Nature has an unbelievable capacity for healing. It is a silent communicator and the ultimate equalizer.

76

The silent cry of a soul

A bilateral mastectomy can be emotionally traumatic for any woman, leaving her devastated. In reality, she is at war with the disease; a war in which there will ultimately be one survivor. The mastectomy can affect her life in many different ways, leaving her with a sense of becoming incomplete. If this happens to you, there may be many reasons why you feel the way you do, both around the time of the surgery, and even much later, even if you do accept the reality of life. It's quite understandable that a mastectomy can make you feel uncertain about a lot of things. And it's natural for this to continue even after treatment has ended. A sense of loneliness is another feeling you may experience in the wake of the procedure. You may find these feelings come and go at different times. And some days they may feel stronger than others.

You may start waking up with the impression that you are numb at some places, a feeling of your womanhood lost and a sting in the soul of a sense of losing your feminine features. The feeling is doubled when you realize that you have ceased to be a woman in the full sense. Sometimes, it makes you want to go back to the times of "complete womanhood". Every woman who has gone through the surgery is likely to have had

gnawing pain in the soul. Outwardly, also, you feel false when you try to look feminine.

It is not just that the breast is generally perceived and accepted with lustful intention; it is also the incompleteness that makes a woman contemplate on her life. Many have fears of how life would be without it. There is apprehension as to whether the bond of love in her life will ever remain the same as before and if she is still beautiful in the eyes of her life partner. These are some of the fears that gnaw at the heart, and it takes courage to get back your confidence as a woman. It takes immense strength to get back on her feet with the realization that physical beauty is only skin deep and it is the inner strength and courage that really matters. However, some people need a lot of understanding from those around to regain that strength and confidence. Others may stand alone and fight, irrespective of what is going on inside; the inner turmoil that comes to gnaw may recur time and again.

It is believed that after an infant is born, when he or she starts noticing things around, the first aspect of life perceived is the mother. When the baby is being breast-fed, the baby gazes at the mother without batting an eye-lid. The baby observes the face and feels the love that is conveyed there. Though the umbilical cord connects the baby to his or her mother before birth, it is the mother's milk that gives the baby life after birth. The breasts are much more than just a tool for feeding a baby. So, when a woman goes through a double mastectomy, it affects her psychologically and emotionally. More than the physical aspect of being feminine it is the pain of the feeling that the warmth of her bosom is gone for any child.

There may be many women who, regardless of their suffering, don't talk of the lump in their breast, for fear of losing their breasts. They may be afraid of how people would view them, and might be afraid to open up about their

misgivings even after the procedure has been completed. There are many among those with mastectomies that do not open up about their fears. Where this is because cancer itself is a taboo, or because of the attitude of people around them, is debatable.

I really wish that the people around had an understanding of the trauma that accompanies the procedure, and the repercussions of the same. Only an understanding of a cancer survivor's inner suffering can bring about confidence and strength. Even with all the loved ones around, it is always a lone battle to be a survivor, regain health and keep up one's quality of life. It may be a daily battle for some, when the consequences of the treatment start creating a big void in life, with many hurdles to cross.

77

Be like a duck

Nature is an amazing teacher. When you learn to observe the things around you, you learn a lot from the sun, the wind, the sky, water or many of nature's delightful living things. When you observe, watch, see and listen to the experiences that nature represents, you open yourself up to an infinite teacher in life.

"Always behave like a duck --- keep calm and unruffled on the surface, but paddle like the devil underneath." This quote brings forth a way to balance life while battling life. You may be going through a lot in life, fighting the battle of keeping alive daily, but why let others know what you are going through. It interest none what you go through, so it is better to smile and stay calm as long as it is possible. When you watch a duck swimming in the pond, it seems very calm and moving without much effort, but none see the under surface struggle of it kicking very hard to keep afloat.

I have been thinking of the duck, comparing it to a cancer survivor or a patient. There may be many people giving in to the disease without a fight, because they don't want to suffer and make the ones around them suffer. There are many who always lament and wallow in self pity making the life of those around too a hell. But the real warrior and survivor stay calm though it is an exhausting experience to stay afloat in the true

grit of life. There is an inner fight beneath the surface that none see.

The daily fights of a cancer survivor may not be known by many and to many, the reason for which may be best known to each individual. Some like to fight it out silently so that the loved ones around are not in fear of what may happen or what is happening. The well known saying that when it rains it pours may describe life at times and to stay calm at such moments needs grit and determination. A duck doesn't run away when it rains, it stays in the rain. Whatever it is they simply endure it. You have to endure it whatever comes your way, enjoying the simple things when they last. Being like a duck is not retaliating and making things worse fight it out in a dignified way staying calm and with an inner fight of never giving up.

78

Gliding through clouds, wishing time stood still

The sky is infinite and boundless; all-pervading, enveloping everything and existing in it, too. The clouds drift like free souls. With the atmosphere around bubbling up like a cauldron ahead of a thunder shower, there is a lot of scope for a spectacular cloudscape in the sky. The hesitantly darkening skies, with the grey invading the blue, conceal the sun behind a thickened veil of billowing clouds; a flash of lightning causes you to hold your breath as the clouds clap thunderously. The revolt in the belly of the sky spills out, pouring down intermittently. It slakes your thirst, putting out the fire in the soul. Beyond the sheet of thundering rain, the sky rumbles with flashes of lightning that threatens to touch all around, hushing up everything. After a thunderous summer shower with streaks of lightning threatening to touch the ground, you experience a sense of electric joy to watch the sky filled with fluffy grey clouds ready to burst open in torrential rain, to watch the clouds in a thunderous applause, waving their lightning wands.

It is bliss to watch the change from a sky covered in grey clouds to a clear blue sky dotted with fluffy white ones. The transition from grey to white clouds is a beautiful experience,

making you feel free like a bird touching the soft fluffy cotton balls; with a heart full of joy and a childlike gleam of wonder in the eyes. The clouds act as nature's filter, making all the difference to the sky, like a magic hour changing colour and mood. Watching the clouds gives you a beautiful feeling. They mesmerize you like cotton candy that has been pulled apart and left to float. It is without doubt a wonderful aspect of nature that is amazingly beautiful and interesting to watch --- the different patterns of the clouds as you glide past it.

The shining clouds are one of the most majestic sights to behold. Even the cloud of a thunderous summer shower is most beautiful. Clouds have always fascinated me. I've always loved finding patterns in them, gazing as they soar high and waiting to float on them as I wished that time stood still for a few seconds at least. Watching these clouds inspire you to get through the negatives and positives of life. There is tranquillity and freedom in the soul as you hold your gaze at the fluffy clouds floating in the sky. They interpret the most unique circumstances in each person's life. In matter of seconds, the clouds can make a difference in the sky, taking it from clear blue to a stormy and thunderous grey; the same happens in a person's life.

The sky is a mirror of life. It does not move, only the clouds do; it proves its stability against all odds. Just like the huge clouds change gradually, imperceptibly, into another, so does a person also, transforming in seemingly tiny ways until suddenly like the clouds that look entirely different, the person too becomes an entirely different individual. The sky with its clouds is a metaphor to observe and understand oneself --- to embrace change despite remaining stable, and staying the same even when you fluctuate yourself. This comes from strength of core stability and a tendency to maintain your stability while manoeuvring the changes.

79

A milestone of life - A crossover or a second childhood?

In the race against time, life is like footsteps in the sand, easily fading away. It depends on the time of life you are at, if you are thinking on it and whether you really welcome the thought. It takes strength and courage to age gracefully, irrespective of what age you are. It is really time to look back on your life, contemplating your experiences, what it did to you and what you have become today. It is the significance and insignificance of life; and the significance of the little things that are usually considered insignificant. It is an insight into the relationships of life, where you failed and what you really gained. A time to record and reflect on the wonderful, fascinating and challenging life you lived.

Age defines a woman at every stage, from an infant to being a grandmother. It is a milestone of all memories, turning into a grand sixty; a treasured milestone that is important in every way, a time to look back at all the good and bad memories that has flown by. It is turning sixty as a woman, not complaining or whining on what went by, looking at how far you have come in life, the family you love and cherishing those fond memories in the sunset of life. It is a graceful stage of elegance, with a rare inner beauty that radiates with the

twinkle in your eyes still intact. You are still full of life, a certain kind of vivacity and a stage where life starts with a new light in your heart and soul.

Every small milestone pops up at you, making you wistfully wonder where the time went. However seemingly small and insignificant the moment may be, it can take you by surprise and lead you to a full life, enjoying all the little things that you have always loved the most. In every aspect of life, it is your strength and confidence that takes you forward. You may have crossed many milestones, facing all the hurdles and challenges; and as you age, it is a time to enjoy the fruits of your labour. It is a time to relive the magical moments of life, even while looking forward to a new learning and experiences.

It is a threshold to an altogether new way of celebrating life, feeling alive and living it to the fullest. While turning sixty may be charged with full positive or negative emotions. Aging depends on the temperament and outlook of each individual. For me, it is a time to cherish all that I have gained in life. I may have erred a lot, hurt a lot, made a lot of mistakes, but I have learned a lot, too, and tried to become a better person than I was yesterday. I learned to value all those I hold close to my heart, but also to give space to all to grow as each he or she likes. My challenges in life have made me what I am today, and made me a stronger person; though emotionally I still remain most vulnerable with the ones I hold close to my heart.

Though I have always been a fighter, I still have my own weaknesses. While I remain a confident and positive tower of strength, I still feel emotional when I am hurt by those close to me. The fight of life battling against life and time has never bothered me, but my relationships that I value always leave me in turmoil. Life taught me the hard way that any relationship can be broken just like that, even if you have taken time and fostered them with love. Still, I value each person in my own way.

Spending time with plants, I learned a lot. A dying plant, even dried one, may sprout new leaves when watered with love, but relationships even when fed with a lot of love can just die. At this stage of life, I have learned a lot the hard way and that still hurts, although all the physical pains have never mattered to me even when I fight a daily battle to maintain the quality of my life. I look for the little things that give me immense joy. Life is always a continuous learning process.

80

The Luring Hills

Everyone has a dream place, where you would like to run away to, and be in solitude, surrounded by nature. I think it is an impulse, that this is the place to be in, the leaping green of the trees, the blue dream of the sky, the steadfast hills, and the clouds that play among the canopy of trees.

A place which is a home to rare flora and fauna; a beautiful grove that is a home to a wide spectrum of birds; spice gardens where the aroma of spices tugs at your nostrils towards the flavour of good cooking. The cool climate of a hill station is another aspect that attracted me towards a respite from the hot climate of Chennai. This is what Thekkady was to me. A beautiful place surrounded by mountains; the attraction of the mountains were the step-farmed tea gardens and the canopy of trees. You could see the whole valley from certain points; and it is a sight that holds you spellbound!

It is indeed a rejuvenating experience to be in a place surrounded by hills. A nature lover finds the place a paradise of healing. It is a beautiful journey through the hills and valleys of the Western Ghats, the boat ride through the Periyar Lake, a walk through the spice plantation, and the beautiful greenery of step-farming on the mountains. The very sound of the name, Thekkady, conjures up the images of elephants

and the unending chain of hills with its forests; the picturesque plantations, also the hill towns and villages. The forests are dense with deciduous and evergreen trees.

The beautiful resorts give you the experience of a joyful holiday. The experience of being in a picturesque place in the silhouette of the hills is beyond comprehension. The hills are a varied green patchwork that keeps changing with the shadows of the clouds. The steep and winding path always creates a sense of adventure. The cool woodland canopy of the hills lures me to just breathe in the air and enjoy the visual treat that is the landscape. The sloping hills, green winding paths, the mist that slowly envelopes the hills, the smell of spices in the sprawling gardens and the high points over-looking the valley are breathtakingly beautiful, and fill me with a child-like joy.

As you travel on the winding roads, you find velvety beds of tea gardens, trimly patched, and the sudden showers turn them into magical carpets, bestowing an ethereal look to the landscape. The hills have a lot of sights to see and explore in its natural beauty and lush greenery.

81

In solitude with an unconditional companion

A nature lover understands how inspiring it is to wake up to the beauty of nature. The cool breeze, chirping of birds on the trees, the sight of playful squirrels, ripples in the cool waters add splendour to your life. A natural habitat facing a scintillating lake in the mountains on one side, and the tranquil ocean and beach on another side can soothe you in the lap of nature, unconditional like a mother. It is a unique way of unplugging from the monotony of life to the inspiration of nature. What you seem to forget in the rat race of life is how to quieten down, look deeper within and open your eyes to the marvel of nature to soothe you.

In the tranquil mind's eye, the tree, the grains of sand, the waves, its ripples, overcast and blue skies, the hills, the leaves, the flowers, all have stories to tell. It is the creative wonder of nature. The rustle of the leaves awaken you to an awareness of their life, the blooming and blossoming of a bud to a flower has a music in it and a story to narrate, if you care to look and listen.

There is nothing more nurturing and soothing to the soul than being one with nature. It is a creative expression that becomes more instinctively immersed in the stillness of a

mountain or the invigorating panorama of a beach. The core of the earth is where its heart lies, with unconditional love that knows only to give in its true nature, until it is pushed to an abusive edge. Nature loves with no restraints or selfish motives, and that is why creativity is enhanced, passions ignited and insight awakened in the company of nature.

I have always loved being one with nature, a perfect companion who understands and bestows. The rhythms of life are tuned to the rhythms of the Earth. The sights, sounds, scents, the feel, and the music of nature are more rejuvenating and inspiring than anything else. It reignites the passions of life, helping you to find your lost soul, that disappeared somewhere in the journey of life.

Leaving the man-made environments behind, to be one with nature, in solitude is a way of reconnecting with yourself, staying grounded, and always healing. No matter how tied up you are with the demands of life, looking far away in the distance of nature, gives you wings to soar high. Everything can be learned from the nature surrounding you. It heals you from feelings of isolation, unworthiness or inadequacy and you start looking beyond the dull pain that your heart and soul feels, and resonates your positive glow.

To be able to connect to nature is invigorating, and waking up to the experience of serenity in nature is most beautiful. Nature has a way of revealing some of your rarest emotions, and spectacular sights. Bringing back those moments of tranquil contemplation in the hectic life captivates the heart.

Printed in the United States
By Bookmasters